# African Americans on Martha's Vineyard

## Second Edition

Edited by A. Bowdoin Van Riper

Edgartown, Massachusetts
Published by the Martha's Vineyard Museum
2017

APPLEWOOD BOOKS
Carlisle, Massachusetts

## PUBLICATION NOTE

The first edition of this work, published in October 1997, contained three articles from the *Dukes County Intelligencer* along with a preface by Della Hardman and an introduction by *Intelligencer* editor Arthur R. Railton.

The current (second) edition, published in January 2017, includes the entire contents of the first edition along with an additional essay, a new introduction, and a bibliography of recent works on the subject. It is intended (as the unaltered title is meant to suggest) as an update of, rather than a sequel to, the first edition.

The first edition was conceived as a "special issue" of the *Intelligencer* and was labeled as such on the cover and the title page. In practice, it was marketed and sold as a stand-alone volume, and the second edition—conceived as such from the outset—abandoned the "special issue" labeling. Neither edition is regarded by the Museum as part of the run of the *Intelligencer*.

## COVER IMAGE

Singer-composer-arranger Harry T. Burleigh, a frequent summer visitor to Martha's Vineyard, poses with young friends—including future Harlem Renaissance writer Dorothy West—on an outing to the Gay Head Light in the early 1920s. Standing (L to R): Unknown, Harry Burleigh, Eugenie Jordan, Dorothy West, Helene Johnson. Seated (L to R): John Mosley, Tom Mosley. *Martha's Vineyard Museum Photo Collection*

# CONTENTS

# ACKNOWLEDGMENTS

This publication would not exist without the hard work of the four authors who wrote the original articles. The guiding editorial hand of the late Art Railton—rivaled only by Dr. Charles Banks for the scope and influence of his work on Island history—shaped all four essays in their original publication, as well as the first edition of this collection.

That a second edition exists, in the form you see before you, is due to the energy and expertise of the Museum staff—particularly Betsey Mayhew, Katy Fuller, and Executive Director Phil Wallis—and to the publishing acumen of Phil Zuckerman and Jennifer Delaney.

Thank you, one and all.

How refreshing it is to know that the narratives relating to black personalities and "men of color" on the island of Martha's Vineyard have been so ably documented in this publication. These three pieces, first printed between 1984 and 1994 in "The Dukes County Intelligencer," fill a major void. Each researcher relates an important story, or series of stories, so often neglected, ignored, or simply not known in years past.

This format enables the reader to have in hand chronicles that provide the sum and substance of minority life on the island that go back to the first quarter of the 18th century. Beginning with the lean years form slavery and moving toward the 21st century, with the presence of affluent late 20th century "persons of color," the reader becomes acquainted with the nuances of life for these minorities in this idyllic setting.

I was a high school student in West Virginia when my aunt,     for whom I was named, first brought me to the island. She was an elementary school teacher with a predilection for history, especially black history. How well do I remember driving along distant highways from my home to New England and being reminded to "take note, Della Louise," when we passed a monument or marker that heralded some momentous event. But what a contrast it was upon arriving on the island to find very little information about the island or islanders about whom I might "take note."

Apparently, when not going to summer school to earn her college degree, Aunt Della frequently spent her days on Cape Cod, working in hotels in Cotuit and Santuit. During my first summer here, she rented a cottage in the Highlands. The

bedroom that I occupied was at the front of the house above the gabled porch. That was during the summer of the Hurricane of '39. I will never forget the electrical storm that struck at the front of my bedroom, near the door. I was terrified!

Of course I was too young to have any sense of the history that was evolving at that very point in time. To think that just up the hill at the Shearer Cottage I might have encountered Harry T. Burleigh, Ethel Waters, or even Madam Evanti among the guests relaxing there. The Adam Clayton Powells were early island visitors and home owners. These were indeed among our mid-century heroes. If only I'd had the perception to "take note" at that precious time in my life.

I have a photograph of my father, a real estate dealer, with island realtor, Eben D. Bodfish. I remember going with them to look at magnificent old houses, not only in the Highlands, but also on Narraganset, Canonicus, and other streets in the Oak Bluffs community. Much to my aunt's dismay, Dad missed this opportunity to acquire land on the island, because he could not resolve "depending upon a ferry to get his car to the Vineyard."

My contact with two of the sons of the Reverend Oscar E. Denniston came after my marriage in 1946. My husband, a musician, played at the supper club where Dean Denniston was employed. That regular contact resulted in a lasting friendship between our families. I remember with great pleasure the stories that both Dean and his brother Madison so often recounted about events in the life of their highly esteemed father.

When I think of the plight of African-Americans on Martha's Vineyard today, I am reminded of the comments of John Hope Franklin in his introduction to The African-Americans: "it is not that racism has been eradicated, or that its multiple offspring of discrimination, segregation, and exploitation have disappeared. It is that African-Americans have learned how better to cope with the forces that operate against them."

As the century ends, persons of color continue to be attracted to the beauty, serenity, and uniqueness of this island. Artists, scholars, sports figures, television and film personalities, writers, businessmen, and journalists all continue to add to the heterogeneous minority community. Many stories remain to be told. I hope this series will provide the incentive for further study into the lifestyles of both black and native Americans who for two centuries have made their presence felt on Martha's Vineyard.

*-Della Brown Hardman, Ph.D.*

# INTRODUCTION TO THE FIRST EDITION

For hundreds of years on Martha's Vineyard, the people of color, mainly Blacks and Indians, were ignored by the generations of notetakers on whom historians rely. How else can you explain their almost total absence in our histories? Even in governmental offices, where records have been required by law, the data on colored folk (as they were usually called) are, at best, skimpy, more often absent.

But this failing was not limited to the Vineyard. It was everywhere. Only in recent years have the contributions to our nation by nonwhites, and particularly by Blacks, become of public interest. Now, finally, we are studying reality, recognizing in our history the accomplishments of minorities.

This assemblage of essays is a start at addressing this omission as it relates to Martha's Vineyard. The three authors in this anthology are among the first to fill this void. Two of them are academics, black women who have spent many summers on Martha's Vineyard. They tell of those black pioneers, early residents and summer visitors, whose names until now have been overlooked by historians, whose accomplishments have gone unrecognized. In these two essays there is emphasis on Oak Bluffs, through the years the Island town most receptive to minorities. Originally part of Edgartown, Oak Bluffs in 1880, much to the hurt of Edgartown's pride, separated from the original town. The reasons were economic, not racial. The new town ran from East Chop to the natural opening of Sengekontacket Pond into Nantucket Sound, about midway to Edgartown village. It was christened Cottage City, but in 1908 the town was given the name it now has, Oak Bluffs.

It was there a decade or so later that Blacks began to vacation and it is there that they are more numerous today. Beginning soon after World War I and accelerating during the Great Depression, middle and upper-class Blacks developed their own summer community in Oak Bluffs. Both authors recount this story, each complementing the other.

The first author, Adelaide M. Cromwell, focuses mainly on Oak Bluffs, describing how it grew into a black

resort. The second, Jacqueline L. Holland, takes a wider view, summarizing the history of Blacks on the whole Island and emphasizing two families whose members have been leading participants in the resort for generations. Both tell fascinating stories, the main characters of which are well-known musicians, entertainers and politicians from Boston and New York City.

The third essay by a Nantucket author who has spent many years researching the Civil War and its effect on the two islands, tells of two colored soldiers, who enlisted from the Vineyard in the Union army. The story is complicated by the incomplete and imprecise records of the time.

In those years, official documents, including U. S. Census records, usually divided the population into only two groups: Whites and Persons of Color. All non-whites, mostly Blacks, Native Americans and Cape Verdeans, were listed as Persons of Color. Because of this, there is no way to determine from those records whether a person of color was an African American, a Native American or a Portuguese American from an island off North Africa.

This is especially troubling to historians of the Vineyard, where these three groups made up an important percentage of the total population. For societal and economic reasons, they tended to live in the same sections of the Island: Chappaquiddick in Edgartown, Gay Head at the western end of the Vineyard and Oak Bluffs on the northeast peninsular. Residential proximity resulted in many "mixed" marriages among the three groups, making racial specificity of descendants even more difficult. This confusion is part of Richard Miller's story.

Altogether, the essays are a valuable beginning to what, it is hoped, will be an increased interest in the history of non-whites on the Vineyard. All three were originally published in *The Dukes County Intelligencer*, the quarterly journal of the Martha's Vineyard Historical Society (formerly the Dukes County Historical Society).

<div style="text-align: right">

Arthur R. Railton,
Editor, *The Intelligencer*

</div>

Edgartown, Massachusetts
July 1, 1997

# INTRODUCTION TO THE SECOND EDITION

The history of Martha's Vineyard is the history of arrivals from elsewhere, of meetings and gatherings. The Island's population has, as a result, always been richly diverse. A hundred thousand life stories have unfolded on these hundred square miles of clay, gravel, and sandy soil, but only a fraction have been told, and the uniformity of their subjects (overwhelmingly, prosperous able-bodied white men engaged in public life) belies the diversity of Vineyarders.

It would be easy to say that the untold stories remain untold because the records necessary to tell them do not exist—easy, but wrong. They do exist, though often in places we are not used to looking and forms we are not used to working with. Overlooking them because they fail to align with our preconceptions of what historical evidence looks like, we risk emulating the man who, having dropped his car keys in the middle of an ill-lit parking lot, persists in looking beneath the lamppost near the entrance because "that's where the light is."

The truth—if we are honest enough to admit it to ourselves—is that the stories of African Americans on Martha's Vineyard have (like those of the Wampanoag and Portuguese, of women and wage-laborers) remained all-but-unwritten because, for centuries, most historians (themselves overwhelmingly white, male, and members of the professional classes) regarded those stories as uninteresting compared to the stories of people like themselves who, they confidently assured themselves and their readers, were the ones who truly guided the course of events. Raised in a world where people of color, as well as women and members of the working class, were assumed to be less capable by nature, too many historians neglected to look for evidence of accomplishment—let alone greatness—among them. They, like most historians of the lands on the far side of Vineyard Sound, viewed the past as if through a captain's spyglass: in intimate detail, but narrowly.

Great strides in broadening that once-narrow vision have been made in the last half-century and especially in the two decades between the first (1997) and second (2017) editions of this volume. The three articles reprinted in the first edition—Adelaide Cromwell on "The History of Oak Bluffs As a Popular Resort for Blacks" (1984), Jacqueline Holland on "The African-American Presence on Martha's Vineyard" (1991), and Richard Miller on "Two Vineyard 'Men of Color' Who Fought in the Civil War" (1994)—were the first significant studies of African Americans

on Martha's Vineyard published in the *Dukes County Intelligencer*, and among the first published anywhere. They varied in scope, sources, and focus but were united by a common conviction that African American history is not peripheral, but central, to Vineyard history. This second edition adds a fourth article—R. Andrew Pierce on "Sharper Michael, Born a Slave, First Islander Killed in the Revolution" (2005)—and could (but for the desire to keep it modest in size and price) have added others as well. The new century has also seen a rising tide of books on the subject (collected in the Further Reading list at the end of this book) and the establishment—under the direction of Elaine Weintraub and Carrie Tankard—of an African American Heritage Trail that spans the island and, at this writing, marks and interprets twenty-four historic sites.

Even amid this rapidly expanding body of historical riches, however, hundreds of stories remain untold. The story of Shearer Cottage and its many guests, famous and less so, has yet to be written in full; Bradley Memorial Church and its dynamic pastor, Reverend Oscar Denniston, await their historian; the story of the Vineyard's role in the Underground Railroad is, at present, scattered—in tantalizing bits and pieces—across crumbling newspaper clippings, oral histories, and other places yet undiscovered. The great age of writing the African American history of Martha's Vineyard is just beginning. This collection is a survey of what has been done and—we at the Martha's Vineyard Museum hope—a starting point for all that will yet be done, in the years and decades to come, by historians who are only now discovering all the wonders that the past has to offer.

A. Bowdoin Van Riper

�✶✶✶✶✶✶✶✶✶✶✶✶✶✶✶✶✶✶✶✶

# The African-American Presence On Martha's Vineyard

### by JACQUELINE L. HOLLAND, Ed.D.

## Introduction

T HE General Court of Massachusetts showed its abhorrence of slavery as early as 1645. However, slavery persisted until 1783 when the state's highest court declared it had no legal basis.[1] The African-American presence on Martha's Vineyard predates the American Revolution (1775) by well over a half-century. Records indicate that African-Americans, even as a tiny minority of servants or slaves, contributed to the growth and development of Island life. Slaves on the Vineyard, as elsewhere in the colonies, were considered common property on which considerable monetary value was placed.

## Estate Inventories and Vital Statistics

The estate of Samuel Sarson, Gov. Thomas Mayhew's grandson, who died August 24, 1703, included "a Negro woman, valued at 20 pounds."[2] Similarly, the estate of Ebenezer Allen of Chilmark, inventoried Dec. 4, 1734, listed Negroes valued at "200 pounds, along with two beds for servants, glasses — one pound, 5 shillings, knives and forks

[1] Allen Bradford, *History of Massachusetts*, 1620-1820, Holland & Gray, Boston, 1835, p.305.

[2] Dukes County Probate (DCP), Index 7, v.1,p.13. Twenty pounds equalled a year's wages for a common laborer at the time. The year Sarson died, Experience Mayhew was paid 40 pounds a year as missionary to the Indians.

JACQUELINE LOIS (JONES) HOLLAND, like great-grandmother Phoebe Moseley, bakes delicious bread, both on East Chop, where she and husband Albert have owned a summer home for 20 years and at Tappan, N.Y., their home the rest of the year. In 1883, when Phoebe first came to the Vineyard, she began a love affair that for more than a century her descendants have kept aglow. Since retiring in 1981, former school principal Jackie Holland has done a lot of traveling, but her heart, like Phoebe's, is on the Vineyard, where she grew up in the home of her grandmother, Caroline D. Jones.

1

at 18 shillings and 600 pair of sheep at 510 pounds and 17 shillings."[3]

The will of Jane Cathcart of Chilmark dated June 25, 1741, did "give and bequeath unto my molato [mulatto] servant, Ishmael Lobb, now in the service of Captain Timothy Daggett of Edgartown . . . his freedom during life after he shall arive at age thirty, which shall be in November, Anno Domini, one Thousand Seven Hundred and Sixty Two . . ." After her death, the inventory taken of her estate in 1750 makes no mention of Ishmael, then only 18. It is not known what happened to him. He may have continued "in the service" of Daggett until 1762, and then been freed, as her will ordered, but we don't know.[4]

Cornelius Bassett, was a "distinguished person," according to Banks's *History of Martha's Vineyard* (v.II). He was a lieutenant colonel in the county militia in 1761, Deputy Sheriff in 1768, Selectman from 1767 to 1773, and a licensed inn-holder from 1761 to 1773. After his death, the inventory of his personal estate included the following:

One Negro boy, Pero . . . . . . . 33 pounds
One Negro woman, Chole [Chloe?], 27 yrs. . 150 pounds
One garll [girl], Nancy, 7 yrs. . 180 pounds

Bassett's total inventory, real and personal, was valued at 11,822 pounds 15 shillings, as of February 23, 1779, making him a very wealthy man.[5]

Records for Joseph Chase of Holmes Hole, who removed to Nantucket (1729 to 1737) and later to Edgartown, show he owned property on the harbor. His and his wife are buried in that town. The Chases left one Negro man valued at 300 pounds and three cows at 40 pounds.[6]

Another Chase, Abraham, whom Banks describes as a ferry operator, inn-holder and trader, was also a resident of Holmes Hole. In his will, probated March 5, 1764, he included as property four Negroes, valued at 54 pounds,

[3] DCP,Index 100, v.3, p.46. Sarson was only 36 when he died.
[4] DCP,Index 196, v.3, p.247.
[5] DCP,Index 369, v.6, pp.162-3.
[6] DCP, Index 191, v.3, p.277.

along with 20 empty barrels, 2 hogsheads, valued at one pound 18 shillings, and 6 featherbeds.[7]

Samuel Bassett of Chilmark, like his father, Cornelius, one of the wealthiest "gentlemen" of the Island, owned land in both Chilmark and Edgartown. His will, probated in 1770, has these items at the bottom of his property listing:

> One Negro woman, two boys . . . 60 pounds
> Pitch forks, scythes, rakes[8]

Other official documents list Negroes as servants, as mariners and under various other job titles. These terms have broad meanings. Generally, servants lived in and took care of the house and the family. Mariners included deck hands, cooks, whalemen, sailmakers, ship's carpenters and even laundrymen, at times.

Blacks, when listed in the town's record of Vital Statistics, were named separately:

> *Births in Edgartown:*
> Chloe: d. [daughter] London [Lunnon] (servant of Jno. Sumner, Esq.) and Violet, bp [baptized] July 1751, CRI [Church of Christ, Congregational].
> Dinah: d. Lunnon "Negro servant to Mr. Sumner," bp October 28, 1744 CRI.
> Mark: child, Lunnon "Negro servant to Mr. Sumner," bp July 3, 1743.[9]
> *Deaths in Edgartown:*
> James, N. m [married]. b [born] Raratonga (South Sea Island). Consumption, May 16 [1846], a [age] 26.
> _____, _____, "a coloured man from ship *Catherine*," Jan. 19, 1835.

This information, sparse as it is, was separated from the alphabetized lists of other names by the heading: "Negroes, etc."[10] As property, it seems, slaves were documented with even less care than most land holdings.

According to historian Charles E. Banks, the first Federal Census in Edgartown (1790) showed these statistics: Total

[7] DCP,Index 283, v.5, p.55.

[8] DCP,Index 333, v.6, pp.43-4.

[9] John Sumner (1705-c.1775) of Edgartown was Harvard educated, served as County Judge, County Treasurer and Representative to General Court.

[10] *Vital Records to 1850*, Edgartown, New England Historic Genealogical Society, Boston, 1906, p.88 (Births) and p.276 (Deaths). No Negro marriages are listed.

population of 1356 whites; 335 males were over 16 years of age and 318 below; 683 "free white" females; and 10 other free persons. Banks says this leaves a balance of ten which "are assumed to be Negroes."[11]

The first Federal Census in Tisbury (also in 1790) lists a total of 1135 whites; 287 were males over 16 years, 238 males below 16, and 609 were females. Also listed were seven "other free persons presumably Negroes."[12]

Chilmark, the third of the early Island towns, could boast of only 73 residents in 1700. But by the 1790 census, there were 760 whites, plus "ten other free persons." These ten were presumably Negroes. All were living in white households.[13]

Eastville was included in Edgartown until Cottage City was incorporated in 1880. At that time, Eastville became part of Cottage City. According to Banks,in 1781 there were approximately 35 families (180 persons) in Eastville. He does not break the total down by race. In 1787, a number of Negro families had an established community in the Farm Neck area, between Sunset Lake and Farm Pond. For a while, Eastville was the largest permanent settlement in the area, continuing even after the campground began in 1835. Negroes were among those living there. The 1880 Census, which did not list Negroes separately, gave the total Cottage City population as 672.[14] By this time, 1880, Eastville had declined in importance, as more residents lived in the new settlement around the campground.

Gay Head, which did not become a town until 1870, has little historical census data, as the early Federal censuses did not include Indians. Even after its inhabitants began

[11] Charles E. Banks, *History of Martha's Vineyard*, DCHS, 1966, v.II, "Annals of Edgartown," p.16. His reasoning is confusing. The Census shows only 8 "Other [non-white] free persons." All were living in white households, no doubt as slaves or servants.

[12] Banks, "Annals of West Tisbury," p.5 and 7. There is again a discrepancy in Banks' numbers. The subtotals of whites add up to only 1134. His seven "Other free persons" is correct, as shown in census data. Two of the seven are separately listed as "Negroes and Mulattoes," not living in white households. The other five presumably are live-in black servants.

[13] Banks, "Annals of Chilmark," p.6.

[14] Banks, "Annals of Oak Bluffs," p.5.

to be counted, Banks explains, "being of Indian extraction and a roving disposition, [the inhabitants] gave little concern to the census takers. . ." There are no racial subdivisions in the record. The population grew very slowly from 160 persons in 1870 to 173 in 1900. We have no way of knowing how many were Negroes, how many were Indians, etc., as Gay Head inhabitants were categorized as "People of color." In the 1850s, Lighthouse Keeper Ebenezer Skiff wrote to the U.S.Government that he had "no neighbors here but Indians, or people of colour."[15]

### News of Freedom Comes Slowly

The facts listed above, when overlaid on the frequency of estate inventories of slaves owned by individuals throughout the Island, lead one to the assumption that blacks were not counted in the early censuses or were listed scantily in vital records during these years.

Though slavery had been declared illegal in Massachusetts, many Negroes continued to live as slaves well into the 19th century. This was often due to illiteracy among the slaves, as they were not permitted to learn to read, or those who could read kept it secret. This resulted in their having little or no comprehension of the law and of the news. A Dukes County Court case, *Edgartown versus Tisbury*, in 1852 provides an example of the confusion.

Edgartown sued Tisbury for reimbursement of money it had spent to support Nancy Michael, a "colored pauper," who, Edgartown claimed, was a resident of Tisbury. Nancy, born about 1772, was the daughter of Rebecca, a slave of the aforementioned Cornelius Bassett of Chilmark. When her mother died, Nancy was appraised and sold at auction to Joseph Allen of Tisbury.

Somehow, "Nancy fell into distress" in Edgartown in 1812 and the town supported her. It sued Tisbury for its expenses. Despite the fact that Joseph Allen had bought her and used her as a slave for some years, Tisbury claimed she had been "born free" and denied any responsibility for her support.

[15] Banks, "Annals of Gay Head," p.5. Also *Intelligencer*, February 1982, "Gay Head Light: The Island's First."

The judge sent the case to the Superior Court. Whatever happened to Nancy or to the case was not reported in the *Gazette*.[16]

Jeremiah Pease in his diary for October 1854 made this entry:

> Attended Meetings at E'ville. Rebecca, a coloured woman, died. She was the Daut. of Nancy Michael, aged about 50 years. She died about 8 o'clock A.M.

The following day, October 30th, Jeremiah wrote:

> Funeral of the above coloured Woman, Rebecca. Service by Rev'd. Mr. Keller.

It would seem that Nancy and her daughter lived in Eastville and to have been mentioned in this fashion by Jeremiah suggests that Nancy and her children were well regarded.

Another slave case reported in the *Gazette* in 1854 highlighted the desperate state of a slave seeking freedom. The ship *Franklin* arrived at Holmes Hole from Jacksonville, Florida, with a stowaway slave on board. The *Franklin's* master, who discovered him a few days after sailing, planned to turn him over to the Customs officer, Henry Pease Worth, in Holmes Hole, but during the night the slave escaped in one of the vessel's boats. He abandoned the boat on West Chop and made his way to Gay Head, where he successfully concealed himself in a swamp for several days, despite the efforts of Sheriff Lambert to capture him.

Two abolitionist women from Holmes Hole learned of the escaped slave's plight, went to Gay Head and, with promises of food, clothing and safety, persuaded him to come out of the swamp. They had brought some female clothing and the fugitive put it on. Thus disguised as "the third woman," he and his benefactors made their way to a boat at Manainshe (Menemsha) Bite. The three "stept into the boat, the warp was unfastened and the already hoisted sails filled to the breeze," minutes before the arrival of Sheriff Lambert. At New Bedford, the two women took the slave to an abolitionist who forwarded him to Canada and freedom.[17]

---

[16] *Vineyard Gazette*, June 4, 1852.

[17] *Gazette*, Sept.22, 29, and Oct.6, 1854.

It is obvious that being a slave taught resourcefulness, cunning, perceptivity and a strong will to survive.

### First Methodist on the Vineyard

Generally believed to have been the first Methodist on Martha's Vineyard was a former slave from Virginia, John Saunders. He and his wife, Priscilla, had earned their freedom through hard work and prudence and were brought to the Vineyard in 1787 aboard a vessel owned by Capt. Thomas Luce. They took up residence in Eastville in a small schoolhouse "standing a few rods east of the Colonel's [Davis] residence." A devout Methodist, Saunders, a zealous speaker and exhorter, "preached to the coloured people at Farm Neck." He and his wife were held in high esteem during the five years they lived there. Mrs. Saunders died about 1791.[18]

In 1792, the widowed Saunders moved to Chappaquiddick where there was also a settlement of "coloured people." There he married Jane Dimon (Diamond), who was of Indian blood. He had a son and a daughter by his first wife, Priscilla, and a second daughter with Jane. All three children were said to have been of good character and to have embraced Methodism.

John was murdered in 1795 by Chappaquiddick Indians. The motive, according to his granddaughter, was Indian opposition to his marriage to Jane, "which exasperated the Indians there, on account of his African descent; . . . [that] and opposition to spiritual religion is supposed to be the cause of his being murdered in the woods."[19] Although it is generally thought that no permanent Methodist Society emerged as a result of his work, Saunders can lay claim to having been the first to bring Methodism to the Vineyard, according to Jeremiah Pease.

### Negroes Attend Methodist Camp Meetings

Beginning in 1835, with the start of the Methodist camp meetings in what is now Oak Bluffs, Negro ministers occasionally came to the gatherings, usually to appeal for

[18] Mrs. Priscilla Freeman's Journal, *Intelligencer*, Nov. 1980. Jeremiah Pease in the same *Intelligencer* says Mrs. Saunders died after moving to Chappaquiddick about 1792.
[19] Freeman, *ibid.*

financial help for their schools or church congregations.

In the meeting of 1867, Rev. Allen A. Gee, presiding Elder of the Nashville, Tennessee, district, spoke about the conditions in Central Tennessee. He described "the rebellious element still smouldering in the ruins of the fallen confederacy." The Freedmen's Aid Society, he reported, had done much for education, but it was hoped "that the system of free schools would be so fully in force in a year or two, as to be able to dispense with aid from that friendly source."

Reverend Gee's goal was to found a college to educate young men as ministers and teachers, to be called the Central Tennessee Methodist Episcopal College. He focused his appeal on helping Negroes of Tennessee by funding institutions of advanced learning.[20]

It was not reported how much money the campers contributed to Reverend Gee's cause, but at another session the same year $60 was raised for a similar purpose. Years before, at the 1844 camp meeting, Brother House of New Bedford made "a very pathetic appeal" for $50 to help "a good colored sister . . . from Brooklyn . . . purchase her son from slavery." Sixty dollars were contributed and "she was heard by a few who stood near her, in a subdued tone of voice which indicated deep emotion, to thank us for our well-timed aid."[21]

### Problems of Post-Civil War Negroes

The work of abolitionists such as William Lloyd Garrison was as much needed during the post-Civil War reconstruction as in the years leading up to the war. The scourge of slavery had set a deep stain across "the land of the free. . ."[22]

On the Vineyard, blacks continued to have troubles. Priscilla Freeman, granddaughter of the first Methodists, John and Priscilla Saunders, was denied rights that she

---

[20] Hebron Vincent, *History of Wesleyan Grove Camp Meeting, 1859-1869*, Lee & Shepard, Boston, 1870, pp.183-4.

[21] Hebron Vincent, *History of Wesleyan Grove Camp Meeting, 1835-1858*, Rand & Avery, Boston 1858, pp. 76-7.

[22] *Gazette*, Feb.7, 1879.

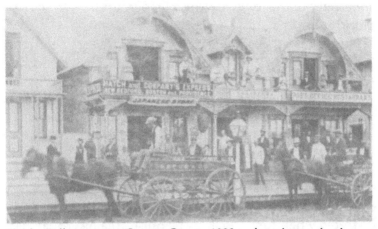

*Phoebe Ballou came to Cottage City in 1883 as housekeeper for the Hatch family. Mr. Hatch owned this express company on Circuit Ave.*

should have had. Mrs. Freeman, who was called "a wronged woman" by the *Cottage City Star*, owned "land bordering on the Tisbury Great Pond, hence [was] one of the riparian proprietors." She requested that the Commissioner of Inland Fisheries include her in the leases that had been given to other riparians. She had been omitted from the list. She petitioned the legislature for help and had gotten other Vineyarders to help her in the petitioning process. The *Star*, which was relatively fair in its treatment of minorities, stated that,

> Massachusetts will not suffer a person to be cheated out of their rights because Indian blood courses in their veins — rather is it a guarantee that their rights will be more equitably accorded them than if they were members of the white race. At least we hope so.[23]

Some years later, the *Martha's Vineyard Herald* reported that "Martha James, colored, renting a cottage (on the Camp Meeting Grounds). . . was refused admission to the campground" because a Mr. Matthews objected to having a colored person lodging next to him. The real estate agent, Mr. Eldridge, did "the liberal thing," according to the *Herald*, and settled Mrs. James into another house, which "she

[23] *Cottage City Star*, Jan.27, 1881. The blood that "coursed through the veins" of Mrs. Freeman was more African than Indian.

preferred to the one on the campground." Or so Mr. Eldridge said.[24]

This occurred despite the fact that two years before, in 1881, when a similar case came up, the Camp Meeting Association had passed this resolution:

> RESOLVED: That we, as directors of the Camp Meeting Association . . . judge it improper and illegal to make distinctions among our tenants on the ground of color.[25]

### Negro Church and Outings

While this worthy resolution seems not to have been strictly enforced on the campground, a multi-racial ministry did develop about 1900 in Oak Bluffs outside the enclave. It started when Rev. Oscar E. Denniston, a Negro, arrived to take charge of the Bradley Mission. A house was provided him on Masonic Avenue from which he ministered to neighboring families regardless of race, color or creed. Soon, he obtained use of the Noepe Hall on Circuit Avenue and there he continued serving the newly arrived Portuguese along with the Negroes. By 1908, the Mission had evolved into the Bradley Memorial Baptist Church. He continued to serve all who came to this church until his death in 1943.

After his death, the church went into decline until 1945 when the Massachusetts Baptist Convention assigned a student pastor to minister to its small, but faithful, congregation. This continued until April 3, 1966, when the church was deconsecrated. Mrs. Mildred Randolph, Miss Susan Tazzel, both of Oak Bluffs, and Mrs. Alice Anderson of Vineyard Haven were, along with the Denniston family, staunch pillars in the church. Mrs. Randolph served as church secretary for many years.[26]

The use of the expression "people of color" to mean all persons not considered white was universal even until the late 1800s. An example of this, and of the confusion it now brings, was published in the *Cottage City Star* in October

[24] *Martha's Vineyard Herald*, July 13, 1889.

[25] *Star*, Jan. 27, 1881.

[26] Bradley Memorial Baptist Church program, "Service of Deconsecration," April 3, 1966. Courtesy Mrs. Mildred Randolph.

1879. Describing the annual cranberry picking at Gay Head, always thought to be only a traditional Indian festival, the *Star* reported in its Gay Head news column:

> The annual "cranberry picking" began on Monday, and swarms of colored people from all parts of the island have gathered here. It would seem proper to name the event "the annual colored frolic," as it is converted into an occasion of social frolic. . . everybody with their cousins, aunts, etc., was present with cranberry rakes, forks, scoops and fingers, ready to get their share. Many persons came for a good time and had it, dancing and carousing until morning seems to be the order of the day on these occasions. Mr. Louis Attiquin opened his new house for a ball.

The Chilmark news column in the same issue reported that "Thirty-three ladies and gentlemen crossed Menemsha Creek in one day last week, bound to the Gay Head cranberry bogs. . ."[27]

### Negroes Take Part in Political Battle

Like Negroes in other parts of the country, those on the Island had not been encouraged to play a role in politics until the bitterly fought election of 1879 over the issue of the secession of Eastville and Farm Neck from the town of Edgartown. For years, residents of that northern end of Edgartown had been petitioning the Massachusetts General Court to make it a separate village.

However, the Island's representative at the General Court, Capt. Benjamin Clough, Republican of Tisbury, was strongly opposed to separation and successfully blocked all action on the petitions. As a result, he was strongly disliked by the Eastville population. The County Republican organization was controlled by Edgartown politicians under Samuel Osborn. In 1879 they nominated Beriah T. Hillman of Chilmark in place of Clough in an effort to placate the secessionists. In exchange, they nominated Clough for County Commissioner "as a reward for past services to Osborn," the *Cottage City Star* wrote. The election was county-wide and a strong anti-Edgartown vote had

[27] *Star*, Oct. 9, 16, 30, 1879.

developed, not only in favor of secession, but also over a controversy about the leasing rights to Tisbury Great Pond. The *Cottage City Star* blasted the Edgartown politicians: "Voters of Dukes County, will you longer submit to the dictation of Samuel Osborn and his followers?"[28]

Disgusted with the anti-separation nominees, the pro-Eastville secessionists called a convention of their own and nominated Stephen Flanders of Chilmark to run against Hillman for Representative and Lorenzo Smith of Tisbury to run against Clough on what was called "The People's Ticket." The election on November 4, 1879, was a close one. It brought out the largest number of votes ever cast to that date. It was the first state election held in Gay Head, which had been incorporated only a few years before.

The vote tally showed that "people of color," as Indians, Negroes and Portuguese were called then, were a critical factor in the election. Gay Head voted 24 to 0 against Clough, the anti-division candidate for County Commissioner. Gay Head also went 23 to 1 against Hillman, the anti-division candidate for Representative. Island-wide, Clough lost by only 4 votes; Hillman by 40 votes. The "colored vote" had been a major factor in the Eastville secessionists' victory.

The anti-secession *Gazette* wrote disappointedly: "We have met the enemy — and we are theirs."

All Vineyard towns except Edgartown voted for separation. However, the Elizabeth Islands, which is the township of Gosnold and part of Dukes County, voted almost as one-sidedly as Gay Head, but for the other side, 15 to 2 against secession. In Edgartown, the vote was 307 for Hillman (anti-separation), 101 for Flanders (pro). The Gazette was critical of the 101 who supported Flanders:

> Single-handed except for faraway Gosnold, she [Edgartown] contended almost successfully against the inexcusable combination formed by the other towns, while the foes in her own household were straining every nerve to accomplish

[28] *Star*, Oct.16, 1879.

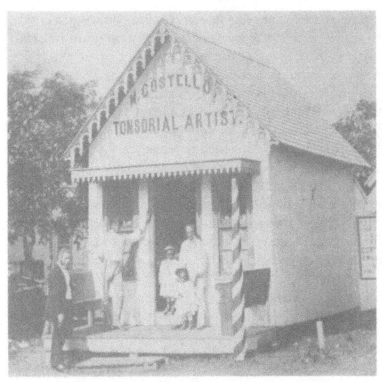

*Black businessmen were rare in 1880. This photo seems to indicate that M.Costello was one. His barber shop was behind Wesley House.*

her defeat.[29]

Editor Howes Norris of the *Cottage City Star* lived in Eastville and had spearheaded the separatist drive. He wrote:

> The people will not submit to the unreasonable and domineering rule of Mr. Samuel Osborn and his clique of sycophantic followers.[30]

Clough was said to be going to try "to have the Gay Head vote thrown out for an informality in the warrant for the election." Norris blasted the idea, writing that any person except "a desperate man would overlook a trifling informality, if there is one, on the part of this young town, officered by our well-meaning colored friends."

The Edgartown establishment blamed the loss of the election on the Negro votes. For the first time, Negroes had

[29] *Gazette*, Nov.7, 1879.
[30] *Star*, Nov. 6, 1879.

played an important role in Island politics and over a critical issue. The election was one of the most important in Island history. With Representative Flanders, a supporter of the Eastville secession movement, elected to the Massachusetts General Court, legislation soon passed separating Cottage City (now Oak Bluffs) from Edgartown.

### Island Press Portrays Negro Stereotypes

During this period, Island newspapers, like those on the mainland, were portraying African-Americans as well as Africans in negative stereotypes. Descriptions of Negroes as infantile, dull and even comical creatures were common in newspaper advertisements and also in short, supposedly humorous, paragraphs which the Vineyard papers picked up and reprinted from other papers around the nation.

In a column entitled "All Sorts," the *Gazette*, with a smile, stated that "Forty tongues are spoken in Africa, but they have only one general way of roasting and eating a missionary."[31]

The *Cottage City Star* advertised a concert at Town Hall on Lake Avenue, Oak Bluffs, this way: "Grand Concert on Saturday Even'g, Aug.1, 1885, by the Original Virginia and Texas Jubilee Singers — A genuine slave band, emancipated by President Lincoln's proclamation."[32]

A news item after the concert stated: "Lovers of good music can spend an interesting evening in listening to these natural vocalists." Calling such accomplished singers "natural" vocalists, as opposed to "trained," seems condescending. Of course, the advertisement, which was surely controlled by the singing group, described it as a "genuine slave band." This, twenty years after the Civil War, seemed to reinforce another stereotype.

Another advertisement, this one in the *Martha's Vineyard Herald*, told of the attributes of Sanford's Ginger, a popular spice. It highlighted two black-faced cartoon heads, one a grinning "darky," the other a happy, smiling melon. Under

[31] *Gazette*, Feb. 3, 1882.
[32] *Star*, July 29, 1885.

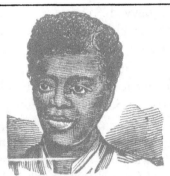

*GRAND CONCERT,*
——AT THE——
## UNION CHAPEL.

Return of the favorites by request. Entire change of programme; consisting of more than twenty pieces of the most popular Jubilee music.

*Friday Evening, Aug. 7,*
——BY THE——
### Original Virginia and Texas
# JUBILEE SINGERS,

A genuine Slave Band, emancipated by President Lincoln's proclamation.

☞Admission 25 cents; reserved seats, 85 cents; children under 12 years, 15 cents. Reserved seat tickets on sale at Leach's Drug Store.

### HARMLESS WITH SANFORD'S GINGER.

The colored brother laughs in anticipation at the feast before him. The melon is tickled beyond expression as it thinks of the kinks it will tie in the darky's stomach. The owl, wise bird, hovers near, knowing that SANFORD'S GINGER will soon be needed.

Sanford's Ginger, compounded of Imported Ginger, Choice Aromatics, and French Brandy, convenient, speedy and safe, is the quintessence of all that is preventive and curative in medicine.

It is sure to check summer complaint, prevent indigestion, destroy disease germs in all the water drunk, restore the circulation when suspended by a chill, and ward off malarial, contagious and epidemic influences.

Beware of worthless "gingers" offensively urged by mercenary druggists on those who call for

### SANFORD'S GINGER.

The Delicious Summer Medicine.   8 4 4t

*Ads in the 1880s. This was the second concert for the Jubilee Singers.*

the headline, "Harmless With Sanford's Ginger," the advertisement continued:

> The colored brother laughs in anticipation at the feast before him. The melon is tickled beyond expression as it thinks of the kinks it will make in the darky's stomach . . .[33]

### A Bonding

Perhaps it was this hurtful kind of newspaper material that fed a natural and necessary bonding of blacks on the Island. Most knew each other by sight, if not by name. By the start of the 20th Century, there were two groups of blacks: the "year rounders"; and the "summer visitors." School Street in Oak Bluffs was mostly white in the early 1900s and blacks lived just off it on First Avenue and on the other

[33] *Martha's Vineyard Herald*, Aug. 14, 1886.

unpaved streets that meshed with "Portuguese Village," extending to the other side of Vineyard Avenue.[34] Some year-round blacks worked for the wealthy white summer people, opening and closing cottages, as well as cooking, cleaning and taking care of their children.

Ms. Sarah Wentworth was one of those "year rounders." She owned her own home at the foot of School Street, where she lived alone. Hers was the last house on the left going "down street", opposite Whiting's Milk Company.[35] Sarah kept a neat, plain, gray-shingled, two-story house, perhaps one of those that had been moved from the campground. It was on the edge of the wetlands in back of Sunset Lake.

In summer, she did laundry for white folks in the Highlands, picking it up and delivering it on her bicycle. A plump, little woman, she would straddle her bicycle nimbly, adjust her black straw hat, setting it squarely on her head. Her hips generously distributed themselves over the bicycle seat as, with the laundry neatly stacked fore and aft, she pedalled very deliberately towards the Highlands. It was, folks recall, a sight to behold and one that commanded respect.

In the evening, it was comforting to hear Sarah's sweet, soft voice through her open curtained windows as she played her piano and sang her favorite Negro spirituals. She was at peace in her home — her own home.[36]

### Reminiscences of Summer

The black "summer visitors," like all summer folk, came and went with the closing and opening of mainland schools. They maintained a warm year-round relationship with the black year-rounders. Phoebe Moseley Adams Ballou was one of them. She first came to Martha's Vineyard in 1883 with her daughter, Caroline, age nine. Phoebe, who was from Paterson, New Jersey, worked for the Hatch family in

---

[34] Pronounced "Portagee Village," a term used to differentiate the Portuguese area from the black section (School St. to Vineyard Ave.).

[35] "Down street": Circuit Ave., or downtown.

[36] John W. Jones, in 1981 taped conversations with the author, his daughter.

the Highlands. The Hatches operated a successful express delivery service between New Bedford and the Island. Phoebe was governess to the Hatch children, as well as housekeeper and cook, and was treated like a member of the family.

Phoebe first lived in the Bradley Memorial Park area off Circuit Avenue. After a few summers, she could see her way to buying her own home out of her earnings and she bought the house next to the Wests on the waterfront near Call's Market.[37] Phoebe added to her income by making fresh bread and rolls for Mr. Call. Sometimes there were over 50 bread pans, loaded with dough, left to rise overnight to be baked in the morning. Phoebe was a hard-working woman and her fresh breads were in big demand at Mr. Call's.

In the summer of 1909, a fire destroyed Phoebe's waterfront home as well as that of her neighbors, the Wests. It ended many happy days for Phoebe's daughter, Caroline, whose son, John Wesley, narrowly escaped death in the fire. His father, Thomas Vreeland Jones, realizing his son was missing, dashed into the flaming building, snatched him out of his bed, and carried him to safety.[38]

This disaster set the stage for Phoebe's next move. She bought a neat, white cottage (which had been moved from the campground) in Bellevue Heights. Since then, four generations have followed Phoebe in the family homestead at 25 Pacific Avenue. First was Phoebe's daughter Caroline and her husband, the hero of the fire; then came their children, Lois Mailou and John Wesley Jones. Next were John's children, Jacqueline and Robert, followed by his grandchildren, Laurence Wesley Holland and Carol Holland-Kocher, Todd Wesley Jones and Stacy Jones-Bevacqua.

[37] Today it is Our Market on Oak Bluffs harbor. The house was a duplex, one half owned by the Wests, the other by Phoebe. It was located on what is now the parking area for the market.

[38] Caroline Jones, in conversations with her grandchildren.

Today, the Pacific homestead is still in the Jones family, more than 100 years after Phoebe Ballou's determined efforts. Her descendants all agree, "the Vineyard is in our blood." One of them, artist Lois Mailou Jones, proudly affirms, "I developed my love for painting on the Vineyard. Menemsha and my mother's beautiful hand-designed hats were two strong sources of inspiration."[39] Today, the internationally famous painter enjoys the title of "Grand Dame" of the art world. Lois describes herself, quite rightly, as an American artist who happens to be black. She "paid her dues" for proper recognition in the United States during the Negro Renaissance in the 1920s and 1930s, having already earned respect, praise and admiration from the French while studying in Paris.[40]

The West family was also among the "summer people." Dorothy, ("a terrific tennis player," Lois Jones recalls) spent many summers here at their waterfront home next to Phoebe's until it was destroyed in the fire. They then moved into the Highlands where Rachel, Dorothy's mother, nurtured her love for writing. Mrs. West kept a great collection of books in her Island house and ran an informal lending library for the neighboring children. They were welcome to take out a book for several days upon promise to return it to Mrs. West personally, often receiving a cookie in exchange. Dorothy's writing skills have made her a nationally known and respected author. Her book, *The Living Is Easy*, which returned to the book stores a few years ago, has been hailed as excellent reading by critics.

The Shearers are another family whose Island history spans nearly a century, having started in 1908. It began when Charles Shearer, a Baptist from Boston, learned of land for sale abutting the Baptist Tabernacle in the Highlands while he was staying at Mrs. Turner's. She was mother of Grace and Marie Turner, esteemed Boston school teachers, and

[39] Lois Jones, taped conversation, 1981.
[40] Artist Lois Mailou Jones, in her 80s, still paints and is exhibiting this summer on the Vineyard. Her late husband, Vergniaud Pierre-Noel, was an internationally known graphic artist.

*Phoebe's house on Pacific Ave. Rear part was moved from campground.*

her doll collection is highly treasured on the Island.

Some years later, Charles bought one of Mrs. Turner's houses. Following that, he purchased a piece of land abutting the Baptist Tabernacle. There he built a bungalow and also a large shed in which he started a laundry, catering to the wealthy white folks in the Highlands. French pleating was the specialty. The women who ironed at the Shearer laundry brought their own irons and kept their own stoves fired. Electricity, of course, was not available at the time. Charles' wife, Henrietta, taught daughter Sadie to deliver the laundry in a horse cart. Another daughter, Lilly, kept the records.[41]

Shearer Cottage was formally opened as a rooming house in 1915 and soon became well known for its airy rooms with fresh, white tie-back curtains. Other attractions included fine family-style meals, a tennis court and a deep, front porch for guests to sit and chat. Board and room, at the time, cost $18 a week. Lilly Shearer attracted guests from New York; others came from Boston and Philadelphia. Well-known black guests who came often to Shearer Cottage included

[41] Taped conversation with Liz Pope White, 1981.

*Composer Harry Burleigh, top, a regular Shearer guest, with Liz and Doris Shearer, children at bottom, who now run the Shearer Cottage.*

Harry T. Burleigh, arranger and composer of such Negro spirituals as "Deep River," "Nobody Knows the Trouble I've Seen," "Couldn't Hear Nobody Pray," and "Were You There?"

The Reverend Adam Clayton Powell Sr., Paul Robeson and Ethel Waters were among the regular guests at Shearer Cottage. Lillian Evanti, a native Washington, D.C., and the first black American to sing opera as a coloratura soprano and later as a lyric soprano throughout the world, visited the Island for several summers in the 1930s as a guest at Shearer. On one of her visits she gave a concert at the Oak Bluffs Tabernacle, which brought prolonged applause from a standing audience at its close. Adam Powell Jr., later bought a house in the Highlands, where his first wife, Isabelle, still summers today. Other Shearer guests, similarly impressed with the Island's beauty, bought homes and continued to spend their summers there.

Shearer Cottage remained a summer guest house for over half a century with Aunt Sadie Shearer Ashburn at the helm, assisted by her nieces and nephews, as well as a few of the children of summer residents, who waited table and worked as chambermaids until it closed in 1971. In 1983,

*Shearer Cottage in the 1920s, a favorite vacation retreat for many prominent blacks from New York, Philadelphia and Boston.*

it was reopened and has continued under Aunt Sadie's nieces, Elizabeth (Liz) Pope White and Doris Pope Jackson. Liz, a playwright, takes pleasure in tying bits of Island history together with stories, such as the following:

> Mrs. Matthews, a dear friend of my mother, Lilly Shearer, ran an elegant dining room and catering service for whites in her home just down the road from the Shearers. A young man, Lincoln Pope, worked for Mrs. Matthews. When he met Lilly, they fell in love and were married in Mrs. Matthews' living room. They had three children, Charles, who died young, Doris and me. As we children grew, Mrs. Matthews' kitchen became one of our favorite places. We loved to watch Mrs. Matthews beat her delicious butter cakes with her hands. If you were invited into her kitchen, you were able to witness that marvel or, perhaps, even be offered one of her scrumptious cupcakes or hot buttered rolls.[42]

About Shearer Cottage, it was said, "There's no place like it . . . blacks like to be together, especially to have fun and relax." Its history has been well guarded; its reputation impeccable.[43]

Another Highland family, also well known for its delicious meals was the Pollards. Son Albert often provided light piano music during mealtime.[44]

[42] Taped conversation with Liz Pope White, 1981.
[43] *Gazette*, Aug. 8, 1986. For more about Shearer Cottage see *Intelligencer*, Aug. 1984.
[44] Taped conversation with John W. Jones, 1981.

# "Summer People": 2nd and 3rd Generations . . .

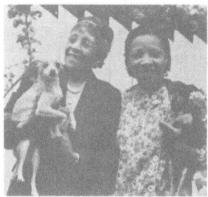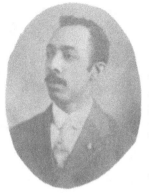

*Phoebe was the first generation, followed by daughter, Caroline, left, with her daughter, Lois Mailou. Right, Thomas Vreeland Jones, Caroline's husband, in 1915 was first black graduate of Suffolk Law School, Boston.*

The Colemans, including Warren and Ralph, actors and entrepreneurs, are another clan whose theatrical and artistic talents have enriched Island life for decades. Luella Coleman, Ralph's wife, one of the original summer family residents, can still be seen driving downtown towards Oak Bluffs from the family compound in the Highland. She, her children and grandchildren now enjoy the Vineyard year-round.[45] She is truly a Vineyard treasure.

### Blacks Give Back to the Island

During the 1950s, two Negro organizations were formed in Oak Bluffs. The first of these began when about a dozen black women formed a club called The Cottagers. It now boasts a membership of more than 200.

"It was friends who just got together to enjoy themselves," explained Delilah Pierce, teacher and painter from Washington, D.C., and an original founder. "Then they decided they weren't really supposed only to enjoy themselves," she continued. "They were supposed to serve the Island."

As a result of the continuing work of Thelma Garland Smith, the group's first president, membership today is at

[45] Luella Coleman, in conversations with author since 1950.

# 3rd, 4th and 5th Generations . . .

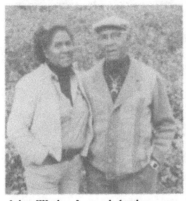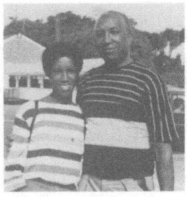

*John Wesley Jones, left photo, son of Caroline and Thomas, with his daughter, Jacqueline, author of this article. Right photo, Albert Holland, Jacqueline's husband, with their daughter, Carol Elizabeth.*

an all-time high and the club calendar is full. Its fund-raising activities benefit such community organizations as the Regional High School, the Women's Services Division of the Community Services, the Oak Bluffs Fire Department, the Rufus Shorter House of the Nathan Mayhew Seminars, the local Chapter of the NAACP, the Oak Bluffs Library, and the Friends of Oak Bluffs. It also funds two high-school scholarships.

In the 1960s, a period of strife, racial and political, in the nation, the Cottagers purchased the former Oak Bluffs Town Hall on Pequot Avenue. There, black women, young and old, provide a series of activities for children, young adults and adults.[46]

The second of these organizations is the Vineyard Chapter of the National Association of Colored People (NAACP) which today has more than 300 members. It has worked with Vineyard schools, providing courses in African-American history for students and teachers, conducted seminars and presented programs to the public. Its most recent programs were a moving playlet on the life of Dr. Gertrude Teixeira Hunter, former professor at Howard University Medical School, and a lecture by Dr. James

[46] *Gazette*, Aug. 8, 1986.

## 4th, 5th and 6th Generations.

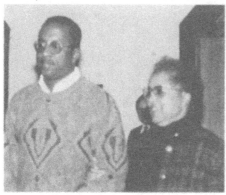

*Left, Laurence Wesley Holland, with mother and author, Jacqueline. Right, his son, Touray Vreeland, 6th generation to summer here.*

Comer of Yale School of Medicine on educational changes and the increased risks therein for black children. Mrs. Maggie Alston, a New Yorker who retired to the Island a decade ago, has been a steady beacon guiding its work.[47]

•

So it is from strong family roots and extended family enrichment handed down by our forebears, that African-Americans have had an active presence on the Vineyard. Today, blacks come to live or to summer with friends from all parts of the Island. They are perhaps echoing a statement recently heard at a dinner party: "I don't know why, but when I'm on this Island, I seem to be able to laugh and to enjoy being with my friends."[48]

Bless all those hard-working, fun-loving souls who preceded us and thus made possible our days in the sun on Martha's Vineyard.

[47] *Gazette*, Jan. 19, 1990
[48] From remarks by summer resident, Helene Wareham, August 1990.

# Sharper Michael, Born a Slave, First Islander Killed in the Revolution

by R. ANDREW PIERCE

I T WAS A HISTORIC MOMENT when the first Vineyarder was killed at Gay Head by the British in the Revolutionary War. We have known of that violent encounter[1] for years and now we believe we know the name of that man, the first Islander to die in the Revolution. He was Sharper Michael, a black man from Squibnocket.

A document in the Massachusetts State Archives, among the papers of the Bristol, Rhode Island, County Supreme Judicial Court, has provided the information. Sharper Michael was born a slave in Chilmark in 1742, he married an Indian from Gay Head (now Aquinnah) in 1775 and, the document indicates, was killed by a musket ball on the beach during a fire fight with a British naval vessel in 1777.

The court file contains details about Sharper and his descendants that provide a fresh insight into the intermingling of Indians and blacks and the presence of slaves on the Vineyard during those early years.

At that Bristol courthouse in October 1816, the "Inhabitants of Westport" were appealing a judgment by the Bristol County Court of Common Pleas denying them reimbursement by "The Inhabitants of Chilmark" for expenses they incurred to support and maintain since 1813, one Harriet Michael, "a poor person found in. . . Westport [R.I.] standing in need of relief. . . [and] having her legal settlement in. . . Chilmark."

The question at issue was her "settlement": in which town

R. ANDREW PIERCE of Boston, a professional genealogist, is the co-author with Dr. Jerome D. Segel of West Tisbury, of The Wompanoag Genealogical History of Martha's Vineyard, Genealogical Publishing Co., Inc.). Volume I, published in 2003, is available from the authors, the publishers and the Bunch of Grapes Bookstore in Vineyard Haven. Volumes II and III will be available in 2006. Mr. Pierce is also co-authoring with Franklin A. Dorman, Native American Families of Nantucket and Cape Cod, 1650-1950, which will also be published in 2006. His address is P. O. Box 6101, Boston, 02114; email: apgen@earthlink.net.

[1] "The Story of Martha's Vineyard," Intelligencer, November 2002, Chapter 3, p. 98.

was she a legal resident, a finding that would obligate the town to support her as a pauper. But the file reveals much more:

> The plts [plaintiffs] proved that the pauper was the grand child of one Sharper Michael who. . . was the Negro slave of. . . Zacheus Mayhew Esqr., [and] was born at his dwelling house in. . . Chilmark about the year 1742 & was the child of one Rose, another of. . . Mayhew's slaves. Sharper lived with. . . Mayhew. . . until a short time before he removed to a place called Gay's [sic] head when. . . Mayhew agreed to emancipate him, but no Bond was given. . . as required by the statue regulating the emancipation of slaves.
>
> That sd Sharper, a few months after removing to Gay's head in the year 1775, was married to one Lucy Peters a native Indian & a free person by whom he had a child named Marcy, the Mother of the pauper. It was agreed that neither the pauper [Harriet Michael] who was an illegitimate child nor her mother ever gained any settlement in their own rights, but the plts contended that the pauper has a derivative settlement from her grandfather. . . Sharper Michael, who had a derivative settlement from his. . . Master [Zacheus Mayhew].
>
> A verdict was taken for the plts by consent of parties, and if from the above facts the Court should be of opinion that the pauper has a derivative settlement from the said Sharper Michael in said Town of Chilmark then Judgment is to be entered agreeable to the verdict, otherwise the plts are to become non-suit.

Ten depositions were entered into evidence, given by a number of elderly people (most of them from Gay Head) who had known Sharper and his family for years. Here are excerpts:

> I, Peter Tallman. . . knew Sharper Michael who was a reputed slave to Zacheus Mayhew. . . in the year 1775, said Sharper came to Gayhead & in the same year was married to Lucy Peters by Josiah Tilton Esquire – I was present and saw. . . [them] joined in marriage. . . Sharper died in Sept. 1777 & Lucy died 5 or 6 years after him. . . I always understood that Sharper Michael was born at the dwelling house of said Zacheus Mayhew Esquire of a woman named Rose, who was an African and a Reputed Slave and I have heard Rose say that Sharper was her son – Rose lived with sd Mayhew until her death.

Ezra Allen, Joel Rogers, Moses Howwoswee, Simon May-

hew and Jonathan Cuff gave similar testimony. Joel Rogers stated that Zacheus Mayhew, who died about 1775, had "promised to free. . . Sharper Michael when his oldest son become of age but he did not stay that time"; and that Sharper "took on Cattle with an intent to keep partly [his wife] Lucy's right [at Gay Head] and [the cattle] ran there until his death."

Rogers said that Sharper was "about thirty years of age" when he came to Gay Head and married Lucy, the widow of Simeon Peters. Mayhew and Rogers both stated that Sharper died in September 1777; Allen, Rogers, Howwoswee and Cuff agreed that Sharper died from "a wound which he received in his head by a musket ball." A violent death, it was.

Many years later, the *Vineyard Gazette*[2] told of the violence (it was also mentioned in the *Gazette*, May 8, 1936):

### The Skirmish off Squibnocket

The following incident occurred here, probably during the Revolution. An American coaster fleeing from an English bird-of-prey, commonly known as a privateer, finding escape impossible was run on the beach and fired. The Englishmen sent in barges loaded with plunderers who put out the fire, but before they had done much looting, Abner Mayhew, who lived on Squibnocket, descended to the beach with his shot gun loaded with buck-shot and opened fire on the gang of redcoats. He managed to conceal himself so well that their return fire did him no harm, while he wounded many, it is not known that he actually killed anyone.

In the meantime, a negro procured a howitzer with which he began to bombard the invaders from the cliff above and they were finally compelled to draw off without having effected their purpose, but with so many wounded that they must tow one of the barges out.

The Englishman. . . stood off and on all day, shelling the coast, but the only damage he did was to a negro whose curiosity led him to the cliff to see what might be doing and who got in the way of an English ball.

It has been no uncommon thing in the past to dig up the small cast iron balls of about three inches diameter, which

---

[2] *Vineyard Gazette*, February 4, 1909, "Stories, Legends. . . Picked Up by C. G. Hine in Recent Trips About the Island." Hardly a solid source of history, but as we shall see, it is bolstered elsewhere.

came ashore at that time.

This *Gazette* account was almost certainly describing the same incident that was recorded by British Capt. John Symons of *H. M. S. Cerberus* in his journal entry on Monday, September 1, 1777:[3]

> at 6 AM saw a sl[oop] off Montock [Montaug] weighed and Gave Chace. . . at 2 PM at Gay head. . . at 4 Run the Chace on shore who prov'd to be a Schooner, Loaded Wt Rum, Sugar & Warlike Stores, Anch'd within Gun shott of her & kept a constant fire upon a Body of Arm'd Men lurking about the Beach while our Boats went & Burnt the Vessell, had 1 Man kill'd & 1 Wounded, ½ past 6 weighed & came to Sail.

Another confirmation of the armed skirmish is that on September 11, 1777, Keziah Coffin Fanning of Nantucket noted in her diary: "News come to [Nantucket] that there was a large number of men of war at the Vineyard burning & destroying there."

It seems probable, when we compare the dates and the testimony given in the 1816 court as well as from Hine's anecdotal account, that the unfortunate man killed by the shots fired from the *Cerberus* by the English was Sharper Michael of Squibnocket.

No other documentary evidence of his fate, or even of his existence, has been found in Vital or Probate Records, or in church records on the Vineyard. Was it not for the two towns' squabbling forty years later over who was to pay for the support of his granddaughter, Harriet, Sharper's story would have not have been saved.

The depositions establish that the daughter of Sharper and Lucy, Mercy Michael, born in 1776, was "put out to be a servant to David Davis of Edgartown," then went to Rhode Island, where she died about 1809. Her daughter, Harriet Michael, born in 1801 (the subject of the court case) was raised in Westport by relatives of Paul Cuffe, the famous sea captain and abolitionist. In 1835, she married Cuffe's nephew, Samuel Cuffe.

---

[3] William James Morgan, editor, *Naval Documents of the American Revolution*, 1980, Volume 9, p. 863.

On July 11, 1903, the *New Bedford Evening Standard* interviewed Sharper's granddaughter, Harriet, who was then 102 years old. An illustration of her was printed along with the interview. She died less than a year later and the *Standard* published her obituary on March 11, 1904. She and Samuel have descendants living today.

Vineyard history buffs may recall the name, Nancy Michael, whose story was told by Jacqueline Holland in "The African-American Presence on Martha's Vineyard" (*Intelligencer* August 1991) and by Elaine Cawley Weintraub and Carrie B. Tankard in *The African-American Heritage of Martha's Vineyard*. Nancy was born a slave of Cornelius Bassett of Chilmark about 1772 and died at Edgartown in 1856.

In 1852, the town of Edgartown sued the town of Tisbury over who was to support Nancy, then an aged pauper (Supreme Judicial Court file #6563, Barnstable County). Depositions established that Nancy's mother, Rebecca, had come from Guinea, Africa, and was also one of the slaves owned by Cornelius Bassett. Nancy's father's name is not given in these papers, nor does it appear on her death record. Nancy had a brother, James Michael, a mariner. He owned a house in Edgartown that he bought in 1795 and which Nancy inherited when he died. In 1819, Nancy sold it, as his "sister and only surviving heir" (Dukes County Deeds, Vol. 21, pp. 71-72).

In 1804 and 1808, Nancy sued two different men for support of her two children who she stated had been conceived at her brother James's house in Edgartown. Her 1804 testimony called him "James Sharper," while her 1808 testimony called him, "James Michael." It is certainly reasonable to suppose that Sharper Michael was the father of both Nancy and James, who were born a few years before Sharper moved from Chilmark to Gay Head where he married Lucy Peters.

Sharper Michael's story, buried for almost two hundred years, reminds us that in the early 1800s Massachusetts was not free from the scourge of slavery. Sharper, who had been born a slave, achieved freedom and built a home among the Wampanoags at Gay Head, only to be cut down in his prime, the first Vineyard casualty in the colony's struggle for independ-

ence. It is an interesting coincidence in history: a black man, Crispus Atticus, killed in the 1770 Boston Massacre, is believed to have been the first colonist to die for independence; and another black man, Sharper Michael, was first to be killed by the British on the Vineyard in the Revolution in 1777.

### Afterword

The story of the Michael/Martin family is remarkable and Nancy Michael was a prime factor. It began in the mid-1700s when two female slaves from Africa, Rose and Rebecca, came to Chilmark. In 1772, Rebecca gave birth to Nancy and it is believed that Rose's son, Sharper Michael, was her father, as she is listed as Nancy Michael in the estate of Cornelius Bassett in 1779, daughter of Rebecca, seven years old, a slave valued at £180. Sharper was killed, as we have seen, in 1777.

Nancy had a brother (perhaps a half-brother), James Michael, who became a mariner and bought a small house in Edgartown which was inherited by sister Nancy when he died.

Nancy Michael never married, but had two daughters: Rebecca Ann in 1804 and Lucy Ann in 1808. She "fell into distress" as a pauper in 1812 and her problems worsened.

Daughter Rebecca Ann was frequently jailed for drunkenness and related misdemeanors. Nancy herself spent five days in jail for debt in 1821. When Rebecca Ann had a son, William A. Martin, in 1827, father unidentified, her behavior didn't improve. She served nine jail sentences after his birth. She died in 1854.

Nancy was William's surrogate mother during all this disorder. He went to sea early in life and by the mid-1800s was first mate of the Edgartown whaler *Europa* in the Pacific. He was promoted to master of the *Golden City* of New Bedford in 1878, making him the Island's first (perhaps only) black whaling master. Sadly, Nancy died in 1856, before grandson William became Captain William.

In four generations, the family had gone from slaves to whaling master. When Nancy died, the *Vineyard Gazette*, in a rare tribute to a black woman, wrote: "She was a most singular character, and it will doubtless be a long time before we shall look upon her like again." (*See back cover.*)

# Two Vineyard "Men of Color" Who Fought in the Civil War

## by RICHARD MILLER

ANY DISCUSSION of the Vineyard's role in the Civil War must include Islanders of color who served in the Union Army and Navy. They have received little or no attention in history. Charles Edward Banks, our leading historian, names 185 army and 110 navy recruits who were credited to Island towns. Research indicates that at least eight were "men of color," although Banks does not identify them as such.[1]

But only two of the eight, James W. Curtis of Edgartown and James Diamond of Gay Head, were actually Vineyard residents.[2] Neither was born on the Island. Diamond, an Indian from Waterford, New York, moved to Gay Head at some unknown date and in 1857 married a Native American, Abiah Manning, daughter of Marshall and Hannah Manning.

The other "colored" recruit, James W. Curtis, was born in Westport, Massachusetts. Although it seems unlikely, he, too, may have been an Indian. He is listed in the 1861 Massachusetts Indian Census as the head of a Wampanoag Indian family on Chappaquiddick. However, in the listing

---

[1] Charles Edward Banks, *The History of Martha's Vineyard*, DCHS, 1966, v.I, pp.518-527. All Civil War regiments were racially segregated. Any private or non-commissioned officer listed by Banks as serving in a "colored" unit must have been "colored," a category that includes a variety of ethnicity.

[2] Banks acknowledges that all those listed were not necessarily Island residents. To fill quotas, towns offered large bounties to attract volunteers from on or off-Island. These recruits were credited to the town paying the bounty, regardless of residence. Further, any man could pay someone to take his place, if drafted. The "subs," as they were called, were usually credited to the town of the man paying. At least 30 of the 287 white soldiers and 6 of the 8 "colored" soldiers on Banks's list may never have stepped foot on the Vineyard. Perhaps, there were other Vineyard men of color who served, but Curtis and Diamond are two soldiers we have been able to verify. See Footnote 4.

RICHARD F. MILLER, a Nantucket-based Civil War historian and reenactor, is a member of the reconstituted 2nd Company, Andrew's Sharpshooters, of the 22nd Massachusetts Volunteer Infantry. He has specialized in the history of the Cape and Islands during that war and is co-author of a forthcoming book, *Nantucket: The Civil War Experience*.

he is described as "Colored, (for'ner), Mariner."[3] Years before, in 1845, he had married a Chappaquiddick Indian, Francis E. Prince, daughter of Lawrence and Love (Madison) Prince.

In the *Dukes County Vital Records*, both bride and groom are described as "Colored," both "residents of Edgartown at time of marriage." The bride, born in Edgartown in 1827, is listed by her maiden name in the Federal Census of 1850, five years after the marriage. She is described as Black (there was no category for Indians, the Census Marshal's choice was White, Mulatto or Black). At that time, she was living in the household of Dr. Clement Shiverick as a maid.

Curtis and Diamond served in the 5th Massachusetts Cavalry (Colored), hereafter called the 5th Cavalry. Both survived the conflict and bore its scars in shortened or painful lives. Their story not only illuminates an important but previously unexamined aspect of Vineyard history, but also provides a view of the experiences of Civil War soldiers of color, Indian or Black.[4]

It is the saga of two very different men who by two very different routes ended up in the same colored regiment. James Curtis took the conventional route. He enlisted for three years on January 18, 1864, shortly after President Lincoln authorized the recruitment of non-whites. On January 29, Curtis was mustered at Camp Meigs, the massive training facility in Readville, Massachusetts, where he was assigned to Company D, 5th Cavalry.[5] His volunteering was

---

[3] *1861 Report of the Indians of the Commonwealth* by John Milton Earle, Commissioner, March 15, 1861, Senate No. 96, Appendix, p.*iii*. In the Report, "Foreigner [for'ner] is used, throughout, in the Indian sense, simply to designate one not of Indian descent." It's certain Curtis's wife, Francis (sometimes Frances) was Indian. In 1892, then a widow, she, along with several other Indians sold Chappaquiddick land, which had been deeded to their families when the Indian Lands were divided, about 1830. The land, consisting of a number of lots, sold for a total of $52.25, of which Mrs. Curtis, then living in New Bedford, received $3.63.

[4] There may have been other Vineyard Indian volunteers. On January 29, 1864, the *Gazette* reported that "a colored man from New Bedford has enlisted five men from Gay Head." The editor demanded they be credited to Chilmark (Gay Head was part of Chilmark until 1870). Who these five Gay Headers were is unknown, but if they joined the army, they have not been identified.

[5] *Military and Pension Record of James Curtis*, National Archives and Records Administration, Washington, D.C. Hereafter listed as *"Records of Curtis."*

praised by the *Vineyard Gazette*, stating that it made "seven recruits towards our quota. We are doing better than some large cities."[6]

James Diamond joined the 5th Cavalry through a very different and unlikely path. Years earlier, in 1858, he and Peter E. Johnson, both of Gay Head, broke into the Chilmark store owned by William C. Manter and stole 50 pounds of flour, 16 pounds of tobacco, six pairs of shoes, 11 pies and assorted other goods including ale, cigars, pepper, sugar, meal, tea and soap. A few months later, they were apprehended. Johnson turned state's witness against Diamond, who was found guilty and sentenced to 10 months hard labor at the Dukes County Jail, having already served four months while awaiting trial. Johnson was sentenced to six months.[7]

In less than two months, Diamond escaped from the jail and was not recaptured for nearly four years. During those years his second daughter was born, making it likely that he was not far from the Vineyard. In May 1863, his return was snidely reported in the *Gazette*: "We learn the jailer is entertaining his old tenant, Diamond, of Gay Head. He tarried about eighteen days."[8]

A jury on September 30, 1863, found him guilty of breaking out of jail and he was sentenced to one year's hard labor. The jury foreman was William Bradley, who was to become state recruiting agent on the Vineyard. As things turned out, Bradley may well have done as much to extricate Diamond from prison as he did in placing him there. This became possible because a major change in the Union's enlistment policy occurred while Diamond was at large.

In the early years of the war, President Lincoln was vehemently opposed to non-whites serving as soldiers, perhaps on political, more than philosophical, grounds. When the Governor of Wisconsin wrote to Secretary of War

---

[6] *Vineyard Gazette*, January 27, 1864. At the time, Edgartown's quota was 42, so it had a long way to go. Tisbury's quota was 37, Chilmark's 13.

[7] *Gazette*, June 3, 1859, also *Court of Common Pleas*, No. 71, May 31, 1859, p.264f.

[8] *Gazette*, May 16, 1863. The editor's comment suggests he was sent to a more secure jail, maybe in New Bedford, while awaiting a second trial.

Edwin M. Stanton in August 1862 asking him if any "encouragement" might be given to those who sought to raise a battalion of "friendly Indians," the Secretary immediately and bluntly expressed Lincoln's position:[9]

> The President declines to receive Indians or negroes as troops.[10]

One month later, Secretary Stanton similarly informed the governor of Kansas of Lincoln's position: "You are not authorized to organize Indians, nor any but loyal white men. . ."

In the summer of 1862, the policy was clear. It was a white-only army. But soon the reality of the battlefield forced Lincoln to take a fresh look. It was obvious that blacks, especially freed blacks from the slave states, were a source of manpower than could no longer be ignored.

"Though he never announced it formally, on New Year's Day 1863, the president had dissolved all the bars against black soldiers."[11] He began urging the enlistment of black units. With high hopes, he wrote to Andrew Johnson, the military governor of Tennessee:

> The bare sight of fifty thousand armed, and drilled black soldiers on the banks of the Mississippi, would end the rebellion at once.[12]

This policy reversal took place far from the Vineyard, but it changed the life of James Diamond, then awaiting trial for jail breaking. No doubt he heard the church bells joyously ring when the Union army scored victories at Gettysburg and Vicksburg in summer 1863. But those victories had come at a high price. More men were needed, many more, to replace the fallen. At the urging of governors, led by Governor Andrew of Massachusetts, Lincoln began

---

[9] *War of the Rebellion, Official Records*, Series III, v.2, National Historical Society, Harrisburg, Penn., 1971, p.297. Hereafter, *Official Records*. The Navy had started to enlist blacks, but with restrictions. On April 30, 1862, Gideon Welles, Secretary of the Navy, announced that contrabands (freed slaves) could be enlisted "freely in the navy. . . as boys at $8, $9 or $10 per month. . . to continue the excellent sanitary conditions [with] the approach of the hot and sickly season." Clearly, they were to be orderlies, not full-fledged sailors.

[10] *Official Records*, p.299.

[11] Howard C. Westwood, *Black Troops, White Commanders and Freedmen during the Civil War*, Southern Illinois U. Press, Carbondale, 1992, p.9.

[12] *Ibid.*, p.vii.

calling publicly for the formation of units of "men of color." The first such in the eastern theater of the war were formed in the freed South, Louisiana and South Carolina.[13] The movement spread north. Rhode Island and Massachusetts, eager to fill their recruiting quotas, actively recruited colored units to be commanded by white officers.

A battle involving the first Massachusetts colored infantry regiment occurred that summer and played a part in the future of Diamond and Curtis, although it is unlikely that either was aware of it. On the evening of July 18, 1863, the men of the 54th Massachusetts Volunteer Infantry (Colored) double-quicked over a sandy beach in South Carolina in a brave but futile attempt to capture Fort Wagner, an impregnable Confederate earthwork guarding the approach to Charleston Harbor.

Though the battle was of little military significance, the stirring accounts of the bravery in combat of the 54th Massachusetts dispelled much of the racist fiction that black men could not or would not fight. The *Atlantic Monthly* spoke for many formerly skeptical whites when it stated, "the manhood of the colored race shines before the many eyes that would not see." Horace Greeley's *New York Tribune* declared that the attack "made Fort Wagner such a name to the colored race as Bunker Hill had been for ninety years to the white Yankees."[14] The nation's pride was so affected that the blue-blood Union League of New York raised a fund to recruit a colored regiment "worthy to stand side by side with the Fifty-Fourth Massachusetts."[15]

The Fort Wagner assault and resultant acclaim accelerated the plans of Gov. John A. Andrew of Massachusetts to form a colored cavalry regiment.[16] Abolitionist and Harvard Law

[13] The very first "colored" unit had been formed earlier in the west, in Kansas.

[14] As quoted in James M. McPherson, *Battle Cry of Freedom*, Ballantine Books, N.Y., 1988, p.686.

[15] *Official Records*, p.1107.

[16] Massachusetts had two colored infantry regiments, the 54th and 55th. Most of their soldiers were not Massachusetts residents: "Although it [the 54th] was a state volunteer regiment, a majority of its men actually came from other states. The regiment attracted some of the finest young black men the North had to offer, including two sons of. . . Frederick Douglass." Joseph T. Glatthaar, *Forged in Battle*, The Free Press, Macmillan, N.Y., 1990, p.135.

School Professor Theophilus Parsons had suggested the idea. When the governor proposed it to Secretary of War Stanton, he replied September 10, 1863:

> My own impressions are entirely in favor of the measure. The infantry regiments raised by you have settled the question of the colored man's fitness for infantry service; and I think that you would be able to demonstrate, in a manner equally satisfactory, their adaptation for cavalry service, which is the only point of dispute remaining unsettled.[17]

War Department approval quickly was given. In the fall and winter of 1863-64, recruiting the 5th Cavalry was begun. It proved difficult. Massachusetts had no great supply of colored men of fighting age. To fill the 54th and 55th Infantry, agents had been forced to seek volunteers as far north as Canada and among the newly freed slaves of the south.[18]

Being Massachusetts residents, Curtis and Diamond were in the minority in the 5th Cavalry.[19] This shortage of volunteers, no doubt, was a factor in the judge's decision in Diamond's case, as reported by the *Gazette*:

> PARDONED.— James Diamond, of Gay Head, who was sentenced by the Superior Court, September, 1863, to one year in the House of Correction at New Bedford, was pardoned on the 4th ult., on complying with the condition that he should enlist in the colored regiment at Readville. He should be credited to the quota of Dukes County, and of the towns, Chilmark, being the most contiguous, should be allowed to count him in her returns, but probably Boston will claim him as she gobbles up all with compunity.[20]

Perhaps it was no coincidence that the same issue of the *Gazette* mentioned that "our recruiting agent, William Bradley, Esq., who is now abroad on this special business,

[17] Quoted in William Schouler, *A History of Massachusetts in the Civil War*, E. P. Dutton, Boston, 1868, v.I, p.491.

[18] Most blacks in the Union army were from slave states: 144,000 out of the 178,000 total. Glatthaar, p.135. See also Henry Greenleaf Pearson, *The Life of John Andrew*, v.II, Houghton, Mifflin, Boston, 1904, pp.91-94.

[19] Living in Massachusetts were only 1973 black males of military age, yet it enlisted 3966 in its colored units. Ira Berlin, Editor, *Freedom, Series II, The Black Military Experience*, Cambridge U. Press, Cambridge, England, 1982, p.12.

[20] *Gazette*, April 1, 1864.

has obtained, we learn, about 25 men, which will give us a surplus for further demands." Indeed, former jury foreman Bradley was in the thick of it, having been hired by a West Tisbury committee to find "substitutes" from off-Island. He would seek out men who were willing, for money, to enlist as residents of West Tisbury, thereby sparing local men from the draft.

And so it was that Curtis and Diamond, both non-white and both Vineyard residents, found themselves in the same cavalry regiment at Readville. They had something else in common besides skin color and first names. Both were 41 years old, 15 years older than the average Civil War soldier.

At his mustering, Private Curtis was described as having a black complexion, black hair, black eyes, and as standing 5 feet 6 inches tall, making him about two inches shorter than the average recruit. He was in good health. Dr. Edwin Mayberry of the Vineyard, who examined him immediately before his enlistment, found him "free from all disease, well and able-bodied."[21] Unfortunately, this would soon change.

Perhaps due to his age, but more likely because he had made a favorable impression on his superiors, Curtis was assigned to the light duties of a guard and orderly at the regimental headquarters. Just before the 5th Cavalry broke camp to move to Washington, D.C., Curtis was furloughed home. On May 5, 1864, he left, the *Gazette* reported, for "the seat of the war" with Company D, 5th Cavalry.

Private James Diamond had already "enlisted," on the order of the court, and was credited to the town of Chilmark, something the *Gazette* had doubted would happen. He gave his occupation as "seaman." Mustered into Company I of the 5th, he was described as having an "Indian complexion," black eyes and hair and standing 5 feet 9 inches tall. One examining physician described him as of the "Indian & negro race."[22]

Although he is shown to have been mustered in March, Diamond was absent from the unit until April 30. Perhaps

21  *Records of Curtis.*
22  *Military and Pension Record of James Diamond,* National Archives and Records Administration, Washington, D.C. Hereafter, *Records of Diamond.*

he had been given time at home after his release from jail. At Camp Meigs, Diamond and Curtis were trained in cavalry tactics, following the system of drill formulated by the Union cavalry general, Philip St. George Cooke. Prescribing a single rank of cavalry, the drill emphasized group movements on horseback. No instruction was given in infantry tactics or in the use of muzzle-loading rifled muskets, the standard infantry weapon. Instead, the men were taught to use the cavalry's breech-loading carbine. This lack of infantry training would have dire consequences for the 5th Cavalry, as we shall see.

The mission of cavalry differed from that of the infantry. It was primarily used to screen friendly troop movements, gather intelligence about the enemy, secure communications and conduct behind-the-line raids. Like colored infantry units, the 5th Cavalry had only white officers, with the ranks, including non-commissioned officers, being entirely men of color.

Eager to ensure the success of his colored regiments, Governor Andrew sought out white officers who were "gentlemen of the highest tone and honor." But blue blood was not enough. As he explained to Francis G. Shaw, father of the young and later famed colonel of the 54th Infantry (Colored), officers should be "young men of military experience, of firm Anti-Slavery principles, ambitious, superior to the vulgar contempt of color and having faith in the capacity of Colored men for military service."[23]

An earnest attempt was made to recruit militarily experienced, socially prominent and politically correct men to lead the 5th Cavalry. Among those chosen were Henry Sturgis Russell, Charles Francis Adams Jr., Francis Lee Higginson, Nathan P. Bowditch and his brother Charles Pickering Bowditch, whose letters about the unit are an important source of its history.[24]

---

[23] Pearson, v.II, p.74.

[24] "War Letters of Charles P. Bowditch," *Proceedings of the Massachusetts Historical Society*, v.57 (1923-24), pp.414-495. Henry Russell would finish his service as a Brevet Brigadier General, as would Adams, whose brother Henry was the famous writer. Higginson and the Bowditch brothers were from prominent Yankee merchant families.

How "superior" some of them were to "a vulgar contempt of color" is open to question. Charles Bowditch, soon to be promoted to captain, thought that the appointment of Henry Russell as colonel was "rather a come round, since he did not used to be quite right on the negro question."[25] Charles Francis Adams Jr., later regimental commander, referred to his men as the "nigs," who might be skilled workmen, but were docile and lacking initiative. "I have little hope for them," Adams said, "in their eternal contact with a race like ours."[26] Even Charles Bowditch, whose letters leave no doubt of his genuine respect for his men and his commitment to abolition, was not without shadows. He doubted whether blacks would be able to "sit up straight" in the saddle, believed they "excelled" at physical work and, he wrote to his father, thought "Negroes [are] the hardest people to reason with that you can imagine."[27]

These attitudes were not without consequence. During Adams's tenure as colonel, near the end of the war, the 5th Cavalry was sent to Texas, there to be "chiefly employed in digging and other laborious work." As a result, according to Adjutant General William Schouler, sick lists swelled because of "exposure and overwork." This changed only after Adams was replaced by Col. Samuel Chamberlain in August 1865.[28]

But for Privates Diamond and Curtis, and for all colored soldiers, there were more obstacles than a few prejudiced officers. Most bothersome was the fact that their pay was not equal to that of white soldiers. Despite the fact that Secretary Stanton declared in August 1862 that colored soldiers must be paid the same as whites ($13 a month plus free clothing, or a $3.50 clothing allowance), his order was ignored until Congress ordered equal pay in June 1864. The pay discrimination was so onerous that some colored

---

[25] *Ibid.*, p.454.

[26] Jack Shepherd, *The Adams Chronicles: Four Generations of Greatness*, Little, Brown and Co., Boston, p.370.

[27] *Bowditch Letters*, pp.441, 454, 469, respectively.

[28] *Annual Report of the Adjutant General of the Commonwealth of Massachusetts for the Year Ending December 31, 1865*, Wright & Potter, Boston, 1866, p.668.

units refused to obey orders, becoming mutineers. It was such a *cause celebre* that Sgt. William Walker of the 3rd South Carolina Colored Infantry (U.S.A.) was executed in late 1863 for leading his company in a "mutiny" against unequal pay. It was more than money, the men said, it was demeaning. The 54th and 55th Massachusetts regiments "even refused Governor Andrew's offer to use state funds to increase their compensation to the amount white privates received."[29]

Colored troops were often used as "uniformed laborers," which added to their anger over unequal pay and with reason:

> Heavy fatigue duty wore out clothing as quickly as it wore down bodies. When black soldiers exhausted their $3 monthly clothing allowance, quartermasters deducted the cost of additional clothing from their $7 monthly pay, thus salting the wound of discriminatory pay.[30]

Another powerfully dissuasive issue existed, one that must have given Curtis and Diamond serious pause: the avowals of the Confederacy to execute all black Prisoners of War who were northern-born freemen and to return to bondage all black prisoners found to be former slaves. Announced by Confederate President Jefferson Davis in early 1863, the policy was never retracted, although it was later modified so that black prisoners who were freemen before the war were given proper Prisoner of War status. Not that such distinctions mattered under combat conditions. Reports of Confederate massacres of black POWs at Fort Pillow in April 1864 and at the Petersburg Crater in July 1864 were only two of many confirmed stories of outright murder and atrocities by Confederates upon colored prisoners.

Following Jefferson Davis's announcement, President Lincoln called on him to treat all prisoners, regardless of color, under the Rules of War, stating that all Union soldiers

---

[29] Berlin, p.21. When Governor Andrew advertised for colored recruits to fill his first colored unit, the 54th Infantry, the ad had stated they would be paid $13 a month (the same as white soldiers) plus state aid for their families. His offer to augment their pay was forced by reminders of that promise. A Rhode Island colored regiment mutinied against unequal pay as late as March 1864.

[30] Berlin, p.24. Although colored privates were paid $10 a month, the $3 clothing allowance was deducted, reducing actual pay to $7.

were equal, black and white. This self-righteous position prompted a black Massachusetts soldier in the 54th Infantry to write to Lincoln pointing out his hypocrisy:

> All we lack is a paler hue and a better acquaintance with the Alphabet. . . We have done a Soldier's Duty. Why Can't we have a Soldier's pay? You caution the Rebel Chieftain, that the United States knows no distinction in her Soldiers. She insists on having all her Soldiers of whatever creed or Color, to be treated according to the usages of War. Now if the United States exacts uniformity of treatment of her Soldiers from the Insurgents, would it not be well and consistent to set the example herself by paying all her Soldiers alike?. . . [pay us] as American Soldiers, not as menial hirelings.[31]

But there was no mutinous fever in the 5th Cavalry where Privates Diamond and Curtis were serving. After a brief training period, on May 5, 1864, the unit, consisting of 893 men and 42 officers, left Camp Readville in a packed train for Washington, D.C. A week later, the regiment was set up at Camp Casey in Arlington, Virginia, one of the defenses ringing Washington.

It was at Camp Casey that James W. Curtis was separated from the regiment. On May 13, the 5th was moved farther south, but Curtis was in the hospital with "Chronic Rheumatism," a catch-all diagnosis that could and often did include almost anything. In Curtis's case, there are indications that he was already infected with the tuberculosis that would eventually kill him.[32]

It was also at Camp Casey that the 5th Cavalry received a major blow, not from the enemy, but from War Department bureaucrats. Charles Pickering Bowditch wrote to his mother, criticizing what had happened:

> Just think of our being here in Camp Casey, turned into infantry and about to drill in Casey's tactics. Horrid isn't it? It is all very well to die for one's country but to be turned from cavalry to infantry for one's country is a very different

---

[31] Harold Holzer, *Dear Mr. Lincoln, Letters to the President*, Addison-Wesley Co., Reading, Mass., 1993, pp.259-60. Soldier Gooding was from New Bedford. His letters from the field were often published in the *New Bedford Mercury*.
[32] *Records of Curtis*.

thing.[33]

Being dismounted, Bowditch hoped, was merely "a temporary arrangement. . . to last only while all the troops are fighting big battles at the front and to prevent any untimely guerilla raid in the rear." But the dismounting of the 5th Cavalry was not temporary. From then on, it was used as infantry. Its station was City Point, Virginia, the burgeoning supply depot and command center from which the final year of the war would be managed.

The monotony of army routine settled over the 5th. "Not much is transpiring here except the arrival of more troops," Captain Bowditch wrote on May 28. While Generals Grant and Robert E. Lee were conducting fierce battles just a few miles away, Bowditch related some of the 5th Cavalry's duties:

> I rather think that you would consider we had something else to do than guard prisoners if you saw the way we have to work. Regularly every morning we have to get up at three A.M., and turn out our companies under arms. After the roll, they stack their arms and go to sleep in the rear of the stacks until five, one officer remaining with the men and keeping awake. At five, another roll-call and men have to keep their equipments on till seven. Then there is an order for five hours drill, which makes nine hours a day for the men to keep their equipments on.[34]

That dreary routine ended June 15. Grant had decided to surprise Lee by sending an advance force south to capture the city of Petersburg, Virginia. The 5th Cavalry, assigned to Gen. Edward W. Hinks's Colored Division, left City Point and advanced west towards Petersburg, 10 miles away. Petersburg was lightly defended by the Confederates and Grant's surprise move had to be accomplished quickly before the garrison could be reinforced.

At one A.M., 3747 troops, mostly colored, consisting of two brigades of infantry, which included the 5th Cavalry, and two batteries of artillery, began the march. Around 7

[33] *Bowditch Letters*, p.473. Casey's tactics were in the standard infantry manual written by Union General Silas Casey. It is no wonder Bowditch was upset. There was an elitist quality to being in the cavalry, astride a fine, well-groomed mount.

[34] *Ibid.*, p. 475.

A.M., four miles before Petersburg, fierce Confederate fire drove back the cavalry which was leading the column, halting the advance.[35]

The infantry was immediately ordered up the road where it made a difficult flanking march through woods and a swamp before halting at a treeline bordering Baylor's Farm, a clearing, nearly a mile square, straddling the City Point Road. It was an effective place for the Confederates to delay the Union advance so as to gain time for reinforcements to reach Petersburg.

The Union soldiers formed two parallel lines of battle. The 5th Cavalry was on the left of the second line. Dodging sharpshooter bullets on that sweltering morning, Private James Diamond had in front of him an open field of standing corn sloping gently upwards, cresting about 400 yards ahead. Atop the rise were Confederate earthworks concealing "some force of infantry" and six cannon with a clear sweep of the corn field.

After considerable delay, General Hinks gave the order to charge. The 5th Cavalry led the attack against raking artillery fire, "furiously assailed with spherical case, cannister and musketry along the whole line." Colonel Henry Sturgis Russell, who headed the 5th in the attack, went down with a shot in the shoulder. Major Zabdiel B. Adams, another senior officer, fell with a shot in the chest. But the attack continued and by 8 A.M., the Confederate works were carried. The defenders retreated towards Petersburg, chased by Union troops. The skirmishing ended at nightfall. Despite the apparent Union success, the over-all attack had been a failure. Petersburg had not been taken as Grant had hoped. Soon its defenders were reinforced, prolonging the war by months.

It had also been a failure for the 5th Cavalry. Trained as cavalrymen, the regiment, forced to fight as infantry, met with disaster. Despite its apparent success in the charge, it was strongly criticized. General Hinks was blunt, calling the

[35] *Official Records*, Series I, v.XL, Part I-Reports, pp.720-723. The account of the 5th Cavalry at Baylor's Farm is compiled from various reports in these Records.

unit (and two other black cavalry regiments involved) "unskilled in the use of muskets and entirely unfitted for operations in the field, by reason of having been taught only the single formations of ranks as prescribed by Cooke's [cavalry] Tactics, and it is impossible to move them in line of battle with any precision, steadiness, or effectiveness. . ." Specifically of the 5th Cavalry, he wrote:

> . . . I placed the Fifth Massachusetts Cavalry (dismounted) on the left of the second line of battle, and its awkwardness in maneuvering delayed my movement fully three-quarters of an hour, and when it finally advanced, though nobly and heroically led, it was but little other than an armed mob. . . Its losses were heavy. . . while its power to inflict injury upon the enemy was nominal. I could but commend its gallantry, but considering its inefficiency, decided that to further engage it with the enemy would be reckless and useless exposure of life to no purpose, and accordingly withheld it from participation in the final attack upon the enemy's works. . .[36]

The 5th Cavalry's poor performance resulted, two weeks later, in it being assigned to guard Confederate prisoners at Point Lookout, Maryland, located on a spit of land jutting into Chesapeake Bay. With the exception of a brief moment of glory when it (perhaps because of its color) was chosen to lead the march into Richmond in early April 1865, the 5th was never again part of the actual fighting forces. Soon after Richmond it was transferred to Texas to serve as a labor unit.

Private James Diamond of Gay Head had been among the casualties at the disastrous battle for Baylor's Farm although not by enemy action. Hospital records do describe his injury as "Contusion — stunned by shell," but Diamond remembered it quite differently in an application for a disability pension he made 26 years later:

> . . . it was a very hot day, we were in the woods and made a charge upon the Rebel Right a Cross the field and drove them back with the capture of one Cannon [and] brought it down to our Camp. My head commenced to ache as it has never done before. I remember of being taken to my

[36] *Ibid.*, Part II-Correspondence, pp.489-91.

tent and laid down. I could not see Very well for some time. How long I laid in that way I am unable to say but the next day I was taken to the Contraband Hospital. . . I have not got over that Sun Stroke from that day to the present time.[37]

First Sergeant Charles R. Douglass, also of Company I, recalled the incident similarly. The Confederates, he stated, were hiding in a large field of waist-high corn. Company I charged the breastworks, capturing the cannon. Several men, including Diamond, were ordered to drag the cannon back to City Point. "[It was, Douglass wrote,] a very hot day, and over a sandy and dusty road. . . Diamond staggered and fell by the wayside, but was assisted on until he reached camp, where for some time he lay in his tent sick."[38]

Sergeant Douglass also recalled that after this episode Diamond always wore a "white bandage or sort of a Havelock" around his head and that due to "severe pain in his head" he was excused from guard and picket duty during the summer months. Another comrade described how Diamond was judged by his peers: "[He] complained of not Being wel, then the Boys cald [called] him lazy."[39]

The other Vineyard soldier in the 5th Cavalry, Private James Curtis, had missed all the action. He was still hospitalized with "Chronic Rheumatism." On June 13, 1864, he was transferred from Camp Casey to a hospital in Alexandria, Virginia, from which on August 5 he wrote to his wife, Frances:

> I now embrace this present opportunity of writing these few lines to you to inform you that i am well at present and i hope that these few lines may find you enjoying the same blessing. I received your kind letter and i was very happy to hear that you got the money. i have been very sick since i sent you the last letter but thank God that i am getting better now only i have got a pretty bad cough. yet i have wrote Down to my regiment about that money, and i have not received no answer yet but the money will be good and if [I] get it i will sent it home. we had a very nice Celebration here on the first of august. i would like you to send me word

[37] *Records of Diamond,* Affidavit, July 15, 1891.
[38] *Ibid.,* Affidavit, Charles R. Douglass, Nov. 7, 1891.
[39] *Ibid.,* Affidavit, George R. Johnson, Nov. 1, 1893.

how [you made] Out with Captain Osborn, wether you have done any thing yet or not.[40]

i suppose that you have heard of the great battle at petersburgh. Our Color'd regiments lost about 1000 more than the whites, all by poor management. Some how my regiment is at point lookout.[41]

i would like you to pay Mr. browning a little something on that Little Debt that i owe him. i would like you to send me all the latest news and let me know [how] your garden Comes on this season and about Wm. Mathews, if he has ever got home yet or not. we have Glorious [religious] meetings here 3 times a week but i still find god precious to my soul.

send me all of the best news for you said that you did not tell me one half of the news. write soon and often and send them to the same place. Direct them to Dr. barker. you had better have that Chimney to the floor this summer and if i was in your place i would have a little fireplace built to it. the next payment that i have i will receive all my back pay and bounty to.

the Dr. thinks that he will try to get me transferred to the navy, that is to go on the water. he says this Country dont agree with my health and he says that i will do better on the water.

Give my best respects to all of the inquiring friends. i am in hopes to get home some time this fall if nothing happens.

Private Curtis did, as he had hoped, get home on a furlough some time later. But he was not well. "He was home nearly two weeks and during all that time was under treatment [for rheumatism] by Dr. Mayberry of Edgartown," Mrs. Curtis stated in an affidavit in 1889. In June 1865 he was judged well enough to be released from the hospital and transferred to Clark's Barracks in Washington, D.C. But a month later he was back in the hospital, this time at L'Ouverture General Hospital, Alexandria, Virginia, with "Consumption," the scourge of the 19th Century. Shortly after, he was diagnosed as a "Convalescent" and transferred to Galloup's Island, Boston Harbor, "for Muster out of the

[40] This may indicate that Curtis, a mariner, had sailed for Capt. Abraham Osborn, one of Edgartown's most successful whalers.

[41] Curtis is referring to the Petersburg mine assault, one of the worst Union disasters. The 5th Cavalry, by this time, had been moved to Point Lookout so was not part of the slaughter.

service." His mustering-out occurred one week later, November 24, 1865.[42]

Meanwhile, Private Diamond, after two hospital stays with problems perhaps related to his sunstroke, in August was considered well enough to rejoin the 5th Cavalry at the Point Lookout POW camp. In a second account, he seems to be saying his sunstroke was not a consequence of the battle at Baylor's Farm:[43]

> After the battle at Baylor's Farm, I was taken sick and was sent to Washington Hospital. . . Upon recovering I was sent back to my Regiment at City Point. . . [they] informed me that my Regiment had gone to Point Lookout to guard the Rebel prisoners. I was forthwith sent with a corps of men to Point Light and in going thither I was received the sunstroke. . . I was informed that I was three miles from City Point when the stroke occurred. . . I was put aboard of Steamer in route to the Portsmouth Hospital. . . [in August] I was sent to my Regiment at Point Lookout. Arriving there I was taken with the lung fever. I was logded [sic] in the Regiment Hospital. In the following Spring we marched to Richmond, Va. After the capitulation of the City noted, we marched again to Point Light. . . the men were examined, those whose infirmities impaired them for service were sent to Fortress Monroe and I was one of that number.[44]

Casual as it sounds in Diamond's account, the march into Richmond was a final moment of glory for the 5th Cavalry, at least according to its colonel. In April 1865, under the command of Col. Charles Francis Adams Jr., the 5th was among the first Union troops to enter the city, the final seat of the Confederate government. That was, Adams said, "the one event which I should have more desired as the culmination of my life in the army."[45] It was followed in a few days by General Robert E. Lee's surrender at Appomattox Court House, bringing the bloodiest war in American history to an end.

In the hospital at Fort Monroe, Virginia, where he was

---

[42] *Records of Curtis*, Transcript, Sept. 25, 1878.

[43] The sunstroke caused memory loss which may account for his confusion.

[44] *Records of Diamond*. Letter to Lawyer George E. Lemon, July 28, 1886. There is no mention of the cannon in this later version.

[45] *The Adams Chronicles*, p. 370.

sent soon after Richmond, Private Diamond was diagnosed as having "lung disease." He was discharged June 4, 1865, on a surgeon's certificate of disability.

Both Diamond and Curtis returned to the Vineyard after the war. Curtis, although never completely well, was for a time able to resume his work as a mariner. His letters to Frances from aboard ship make it clear he still had health problems. "i have a bad Cold at present and dont feele very well Just now," he wrote aboard a ship in Boston in 1871. The next year, he wrote from New Orleans, "I have been very sick with the diarrhaea and rheumatism [and] I thought at one time I should have to go to the hospital." Away from home, he continued to find comfort in religion: "Since I have been here [in New Orleans] I have been to [prayer] meeting every night which I have enjoyed very much."

While on the Vineyard, he was under the care of Doctor Mayberry of Edgartown, who testified after his death:

> His health was uniformly good till after he enlisted in the Union Army in 1864. During the fatigues and exposures of a soldier's life, Aneurism of the thoracic aorta came on, from which he never recovered. . .

On December 2, 1875, Doctor Mayberry had him taken to the Marine Hospital at Chelsea. It was his final hospital stay. The Chief Surgeon of the hospital signed his death certificate: "James W. Curtis, colored, aged 56 years, a native of North Carolina. . .died March 7th, A.D. 1876, of Aneurism of the Thoracic Aorta." The day before he died, Curtis had written to Frances:[46]

> Dear wife
>
> I set down to write you these few lines to let you know that I am not improving much here for these last two or three weeks past wich I've had a very severe atack of fever and I'm geting little better now and i'm in hope this will find you and all the family enjoying the blessing of good health.
>
> Well, as I told you I was geting better. i am in hope by the end of the week if the weather continues so, I'm in hope I shall be able to come home, for the president of the Christian society promises to send me home. just soon I am

---

[46] *Records of Curtis*, Contemporaneous records show he was born in Westport, Mass., not North Carolina.

able to travel and weather gets better I shall come home.
I've receive your letter and the money you sent. Give my
love to the children. I have no more to say and god bless
you all.

Four days later, the *Gazette* carried his obituary:
DIED. CURTIS — At the U.S. Marine Hospital, Chelsea,
7th Inst., Mr. James Curtis of Edgartown, aged about 50
years. (Mr. C.'s life was insured for $1000) [47]

The Vineyard's other soldier in the 5th Cavalry, Private
James Diamond, also did not go with the unit when it was
shipped to Texas because he was still in the hospital at Fort
Monroe. On June 4, 1865, he was "discharged for disability"
and, it seems, was paid $300 bonus plus $17.55 unused
clothing allowance. He returned to Gay Head where, in
1870, the Federal Census listed him as a mariner, 50 years
old, living with his wife Abiah, age 48. Together, they owned
real estate valued at $800. Like many former soldiers, he
joined the Grand Army of the Republic, the principal Union
veterans' organization. Although the Vineyard had a GAR
post, Diamond joined the one in New Bedford. We don't
know that the Vineyard GAR was racially discriminatory,
but such a policy was not uncommon.

His health continued to decline. By 1883, wife Abiah had
left him for non-support. He continued to seek service-
related disability benefits based on his sunstroke, but was
always denied. However, he was drawing a pension because
of "Rheumatism and Senile Debility."

In his weakened condition, he received considerable help
and sympathy from his Gay Head neighbors. During the
1880s and 1890s, physically unable to fish or farm seriously,
he was often hired by Gay Headers to work in their gardens
and around the property. One neighbor stated that she saw
him "on a average of four times a month" and that at best
he could perform only "light work about the farm and
house." Laborers were paid from one to two dollars a day,
but "James Diamond could not do any of the work that
demands the above wages," she said. [48]

[47] *Gazette*, March 10, 1876. It is curious that the insurance amount was included.
[48] *Records of Diamond*, Affidavit, Rossana G. Rodman, Jan. 1887.

Thomas Jeffers, another neighbor, testified in 1895:

> I have known James Diamond since he came from the war.
> he has not been able to do about one third of mans work
> a day, but he is not able to work any now. he is in bed
> most of the time the last month on accont of the disability
> incurred during the late war. he is a great sufferer and under
> the doctors care. his sickness is disease of the lungs and
> general disability in consequence of sun stroke.

The West Tisbury doctor, Courtland de N. Fairchild, also provided an affidavit in support of his sunstroke claims:

> The first time I treated him [March 15, 1893], he was
> suffering from "oedema of the lungs" which he is subject
> to. . . He is unable to work out in the sun as it affects his
> head very bad and says it dates back as far as when he had
> the sun-stroke at "Bayler Farm, five miles from City Point,
> James River," while he was in the war. My last visit to the
> claimant was March 1st, 1895, he having fell over a stone
> wall and causing a very bad sprain of his ankle joints, which
> prevents him from doing anything towards the support of
> his family. It will be a long time before he can use his foot
> as it is a bad sprain and he is an old man. He is confined
> to his bed.

Despite rejections, veteran Diamond continued to file claims for the sunstroke and lung disease he said he had contracted in the service. It seemed important to him that the Pension Bureau recognize his service-related disabilities, perhaps to validate the sacrifices he had made. Written in a shaking hand, one of his early pleas for such recognition survives:

> I have been advised to apply for a Pension as a Soldier
> honorably entitled to the same and in My poor way have
> tried to do so hoping you will kindly and generously
> consider me and be assured that I am not trying, after
> serving My country, to defraud it. So please excuse all
> mistakes for My education is poor and memory shattered.[49]

Former Private James Diamond died at Gay Head on March 27, 1897, age 74. No mention of his death appeared in the *Vineyard Gazette*. His widow, Abiah (Manning) Diamond, received a pension of $8 a month until December 4, 1905, when payments ended "because of [her] reported

---

[49] *Ibid.*, Letter, Diamond to Attorney George Lemon, April 14, 1884.

death. Date unknown.".[50]

We know that Diamond was an American Indian and it may be that Curtis was also. But to the War Department it made no difference. Both were simply "men of color" who served with Northern Blacks and Southern freed slaves under white officers. Their war experiences give a more accurate picture of the fate of Civil Warriors of color than the currently popular image of gallant black regiments in heroic charges against entrenched Confederate positions. To be sure, such desperate charges did take place. The terrible losses suffered by colored troops at Fort Wagner and the Crater at Petersburg are ample evidence of that. But there is no denying that Curtis's belief in white-officer mismanagement of colored units was often accurate. It was as true for the 5th Cavalry at Baylor's Farm as it was for the United States Colored Troops at the Crater.

The men of the 5th never had the opportunity to perform as cavalrymen for which they had been trained. That promise of fighting as mounted cavalry, like the promise of competent white officers, was not kept. By the end of the war, the 5th Cavalry had become a misused and abused labor battalion in Texas.

This was only part of the broken promise. Colonels Henry Sturgis Russell and Charles Francis Adams Jr., came out of the war as highly praised brigadier generals. With the failure of Reconstruction and the bloody Indian Wars that followed, it cannot be said that "soldiers of color" like Vineyarders Curtis and Diamond fared as well.

[50] *Ibid.*, Pensioner Dropped Form, August 28, 1906.

# The History of Oak Bluffs
# As a Popular Resort for Blacks

by ADELAIDE M. CROMWELL

## Resort Life of Black Americans

IN his amusing and throughly documented book, *The Last Resorts*, Cleveland Amory explains how and where the rich and the very rich Americans recreate during the summer.[1] The rise and fall of the more famous watering spots such as Newport, Palm Beach, Bar Harbor and Narragansett are all included, as well as some less well known, such as Lenox and Cape May.

Blacks, too, as soon as they could afford it, followed paths similar to those of comparable Whites and sought convenient watering spots. On the Eastern seaboard, there are at least three (four if one includes Cape May) black resorts: Highland Beach on the Chesapeake, comfortably accessible to the black communities of Washington, Baltimore and Philadelphia; Sag Harbor on Long Island; and Oak Bluffs on Martha's Vineyard.

Highland Beach, a name often incorrectly used to include Venice Beach, Ocean Harbor and Arundel-on-the-Bay, in addition to Highland Beach proper, was established, as was Idlewild, a little known black resort in Michigan, by black initiative. Most other black resorts

[1]Cleveland Amory, *The Last Resorts*, Harper and Brothers, N.Y., 1948.

ADELAIDE M. CROMWELL is Director of Afro-American Studies at Boston University. Earning her Ph.D. at Radcliffe College, she has been on the faculty of Hunter College, Smith College and Boston University, where she is Professor of Sociology. A member of the Society, she has summered on the Island since 1943.

followed the usual pattern of black year-round communities, developing as part of the white communities surrounding them. Oak Bluffs and Sag Harbor illustrate this more typical pattern.

The first Blacks in these places were year-rounders seeking work in the more favorable northern environment. Initially, these Blacks did not form a separate community, being rather a collection of individuals who were able to survive in the local economy. Soon, however, they established their own institutions: first, and always, there was a church, followed, in some cases, by a school. These settlements differed little from other small groups of Blacks that moved into the north except that they were in communities that changed radically from winter to summer, thus altering the employment opportunities.

A second group of Blacks came just in summer and included some who would work only for Whites. Others, more entrepreneurial, set up guest houses and small hotels run by and for Blacks, anticipating the desire of the more affluent Blacks to seek vacations away from the city despite almost universal housing restrictions.

The third group of Blacks was made up of those who came on vacation as a leisure class, often, at first, as paying guests in the Black-owned guest houses and later returning to purchase their own homes. Who these leisured Blacks were, the cities from which they came, their occupations and the life style to which they were accustomed always altered the character of these resorts. Their arrival never eliminated the other groups of Blacks, it only made more complex the character of the black community.

In addition, of course, there were those Blacks who avoided all popular resorts, preferring to vacation as individuals on the Cape, in the mountains or at the lakes where they neither found nor sought year-round or summer communities of Blacks.

Today, for a variety of reasons, the black resort at Oak Bluffs is extremely popular and it illustrates by its history and social structure the complexities and the changes in black resort life styles.

### The Coming of Blacks to Oak Bluffs

The first Blacks on the Vineyard were probably slaves, for slavery was legal in Massachusetts until 1783.[2] There is in the Society Archives a document reporting the sale of a Negro woman by Wilmot Wass in 1769. The idea of servitude was not quick to die after 1783, however, as John Saunders was apprenticed by his father to Melatiah Pease of Edgartown for 17 years on "the nineteenth day of January in the year of our Lord 1793."[3] Ironically, John was probably a son of John Saunders, mentioned later, who is thought to have brought Methodism to the Island. He died in 1795, two years after his son's apprenticeship began.

After slavery became illegal, Blacks from such "havens" for free men as New Bedford had come to work on the ships as laborers, sailors and craftsmen and ended up on the Island. Many of these early pioneering families married members of the indigenous Indian population who, by the end of the 18th century, were being pushed to Chappaquiddick and Gay Head, opposite ends of the Island.

Even so, the black population remained small in the 18th century. A Commonwealth Provincial Officer in 1765 counted 46 Blacks. In the American Revolution, a census enumerated 59 Blacks, two percent of the population. Fourteen years later, in 1790, according to the first Federal Census, only 39 Blacks lived on the Vineyard, one percent of the population. For the next 100 years, the

[2]William Warren Sweet, *Methodism in American History*, Abingdon Press, Nashville. 1953 revision, p. 230: ". . . at the opening of the Revolution, Massachusetts alone had more than six thousand [slaves]."

[3]D.C.H.S. Archives. Melatiah Pease (1714-1832) was a master mariner who probably had retired and was running a business at the time.

year-round black population was never more than four percent, sometimes dropping to under one percent. There were small peaks, however. In 1800, 1870 and 1880, the black population rose to over 200, six percent or more. Between 1880 and 1890, the black total dropped from 275 to 132, increasing in 1910 to 193 (4.2 percent). By 1940, Blacks totalled 295 (5.2 percent), but in the next ten years there was again a decline to 160 (2.8 percent). By 1970, Blacks were 3.3 percent of the population with 207 persons.

Religious revival meetings were an important factor in the settlement of both Whites and Blacks in Oak Bluffs. The establishment of the Wesleyan Camp Ground in 1835 led, years later, to the town of Cottage City, later renamed Oak Bluffs. According to some persons still alive, it is only recently that Blacks have been welcome as residents on the Camp Ground. There is, however, good evidence that there were occasional Blacks in attendance at the August Camp Meetings.

Certainly, Blacks were involved in the growth of Methodism on the Island. The first persons known to profess being Methodists here were a colored couple, John Saunders and his wife. Having purchased their freedom in Virginia, they sailed for Massachusetts in a coastal vessel which laid over in Holmes Hole where the Saunders couple decided to stay. That was in 1787. "John, being an exhorter (having as is understood held this position among his fellow slaves) preached occasionally to the people of color, at 'Farm Neck.'. . . In 1792, Saunders removed to the adjacent island of Chappaquiddick, where there was also a settlement of colored people . . . and where he died in 1795."[4]

Saunders' preaching, however, did not lead to the formation of a Methodist Society as it was not until the 1800s that such organized meetings began and then almost

[4]Charles E. Banks, *The History of Martha's Vineyard*, v. II, Annals of Oak Bluffs, p. 45.

in secrecy there being so much opposition from the established religion. Incidentally, the fact that Saunders apprenticed his son for 17 years may suggest a concern for the boy's welfare and training rather than the existence of any broad program of indenture for Blacks.

At the Camp Meeting of 1856, Father John F. Wright of the Colored People's College in Ohio (it is now Wilberforce) was one of several senior preachers. In addition to his sermon, he preached twice in tents to smaller groups. His preaching was described as "able, thorough, and filled with evangelical fire -- just such as we might have expected from one of the apostles of Methodism in the West."[5] Father Wright was given special permission, against the usual policy, to collect money for his college. He collected $100.

Two years later, in 1858, the "famous negro Henson, said to be the original Uncle Tom of Harriet Beecher Stowe's well-known romance, visited the meeting and exhorted."[6]

It is important to note that a famous Oak Bluffs resident in the 1870s was Methodist Bishop Gilbert Haven, an anti-segregationist who "employed 20th Century freedom-rider and sit-in tactics during his travels. In 1873 in Mississippi he rode in a train car 'reserved' for colored passengers and ate in a Negro hotel in Vicksburg." He was white, of course, but he was the friend of black people being "one of the few men of his day who unflinchingly favored social equality, including the removal of all laws forbidding interracial marriage," a revolutionary idea at the time.[7] It was at his cottage on Clinton Avenue that President Ulysses S. Grant stayed during his visit to Oak Bluffs in August 1879. The President occupied a seat on

[5]Hebron Vincent, *A History of the Wesleyan Grove Camp Meeting*, Rand and Avery, Boston, 1858, pp. 113-4, 162-4.

[6]Banks, *op. cit.*, p. 26.

[7]Frederick A. Norwood, *The Story of American Methodism*, Abingdon Press, Nashville, 1974, p. 273.

the platform when the Bishop preached to the gathering on Sunday.

Although this was a period in history when the fervor for abolition and concern for Blacks had subsided, it is significant that there exists an undated photograph of a group of serious, neatly dressed Blacks posed beside the Preachers' Stand of the Camp Ground. Perhaps they were there as part of the group that welcomed President Grant. This picture and that of five black women outside the Promenade Hotel on the boardwalk were made by photographers Richard C. Woodward and Son whose work covers the period 1871 through 1888. Two other photographs from the same collection -- the staff of Narragansett House and Tom the Shoe Shine Boy -- are evidence of occupations followed by non-leisured Blacks at the time.

A somewhat later photograph portrays a well dressed group of Blacks at the turn of the century posing in front of an Oak Bluffs rooming house, probably on the Camp Ground, known as the Thayer Cottage. Until recent times no Black was known to have owned a cottage on the Camp Ground or even to have been welcome there as guests. So strict was this policy that, according to one source, the first guest house in Oak Bluffs open to Blacks was run by Mrs. Anthony Smith and though originally a cottage on the Camp Grounds, it had to be moved outside before Blacks could occupy it.[8]

### From 1900 to World War II

For almost 50 years after 1900 the growth and changes in the black community were gradual and hardly visible to those outside its boundaries. Two identifiable groups came to augment its size, one year-round, the other in summer. In 1893, a white minister, Madison Edwards, headed a church in Vineyard Haven near the wharf, the Seamen's

[8]Author's interview with Mrs. Barbara R. Townes.

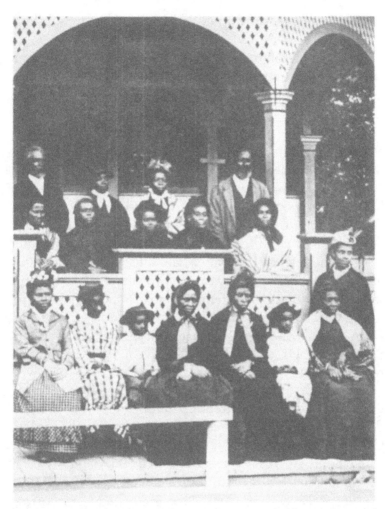

*The two men in this photograph, c. 1875, were probably preachers at the Camp Meeting. The latticed structure is the Preachers' Stand.*

Bethel. Its mission was to provide religious guidance and hospitality for sailors while they were in port. While on vacation in Jamaica, Reverend Edwards met the Rev. Oscar E. Denniston, a black man who performed mission work in Kingston. Edwards persuaded him to come to Martha's Vineyard. Reverend and Mrs. Denniston came to the Vineyard in September 1900 and ushered in a major

change in the black community. Now it had an established leadership.[9]

The black community at the time was closely knit and "took pride in themselves." It was a small group. In 1920 only 175 Blacks were year-round residents of Dukes County.

Reverend Denniston started his work at Oakland Mission, later called Bradley Memorial Church, at 11 Masonic Avenue in Oak Bluffs. His wife, Charlotte, by whom he had three sons, died in 1905. One of their sons, Madison, still summers on the Vineyard. Later, Reverend Denniston married Medoria A. Curtin. Five children were born of this union: Olive, Baron, Dean, Amy and Gerald.

Reverend Denniston was a good fisherman, catching many hake which he salted to feed his family over the winter. The children attended public schools, although son Madison completed his high school studies in Boston. Dean, the second son, graduated from Oak Bluffs High School in 1931 in a class of twelve. All the children received further education and spent their working lives off-island. Dean received a B.A. and M.A. from Boston University, Madison attended Suffolk University Law School. Olive and Amy received B.A. degrees at Gordon College and did graduate work at Boston University, going South to teach, a pattern frequently followed by educated Blacks for whom there were few opportunities in the North. Baron and Gerald also graduated from Boston University. Gerald worked for the Federal government while Baron completed his medical education at Harvard. Madison, Dean and Olive all have homes in Oak Bluffs.

A true picture of just how Blacks fared at the time on the Island depended a good bit on who was evaluating the situation. The closest friends of the Denniston children were Blacks. One member of the group remembers being

[9]Documentation on this period comes from interviews with Madison Denniston and others conducted by Joseph Brown while a student in Afro-American Studies at Boston University.

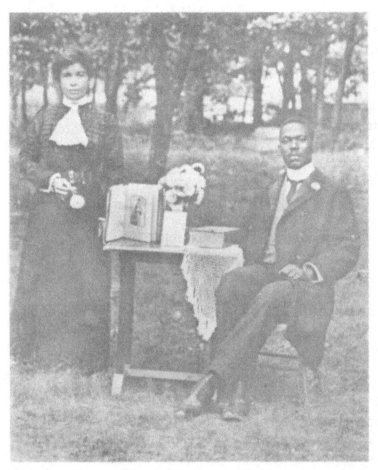

*Rev. Oscar Denniston, here with his wife, Charlotte, was minister of Bradley Memorial Church, Oak Bluffs, early 1900s, a key figure in history.*

called "Nigger." Everett S. Allen in his recent book on the Vineyard noted the alienation and isolation of both Indians and Blacks, but as an outsider to both worlds perhaps he was not in the best position to know the vitality and inner strengths of these separate communities.[10] His assessment, however, is probably quite in keeping with the view the white community, in general, held of its black and Indian neighbors.

[10]Everett S. Allen, *Martha's Vineyard, An Elegy*, Little Brown, Boston, 1982, pp. 192-214.

Madison Denniston recalls about 30 individuals in the Oak Bluffs year-round community of Blacks during the early years of this century. Among them were John Pollard, a Civil War veteran who ran a dining room in the Highland section, and his sister-in-law, Mrs. Matthews: another was Mrs. Sarah Wentworth, from New Hampshire, mother of three boys, one of whom, Arthur, was the first black graduate of Oak Bluffs High School; George Wormley, who owned the gasoline station on New York Avenue (now deBettencourt's); George Frye, for many years a cobbler on Circuit Avenue and his wife, Ella; Medie Wright and her sister, Nellie Hooks. Others included John Green, Amos Haskins, John Randolph (lost at sea), Virginia Swann, Mrs. Tilman, Mable Hughes and Mrs. Kibbie.

Gradually, there was a social merging of the permanent residents and the summer people. This was possible, perhaps, because many of both groups were business people, thus making it easier to mingle on the Island.

A glimpse into this merged community can be gleaned from the August 7, 1933, column entitled "Oak Bluffs Breezes," a regular feature of the Boston Guardian, the famous black newspaper started in 1901, edited by William Munroe Trotter and sold to summer residents by Madison Denniston as a boy. Unfortunately, few copies of the newspaper have survived, but this 1933 issue gives a good picture of social life of Island Blacks.

The column verifies the importance of Reverend Denniston and his family as well as of some summer residents, most of whom were from Boston, this being a Boston newspaper. The illness of Reverend Denniston, "well-beloved and progressive pastor of the Bradley Memorial Church," is noted as are several church activities. Birthdays, condolences and the comings and goings of summer visitors from Boston and Providence are reported. Attention is given to Shearer Cottage on the

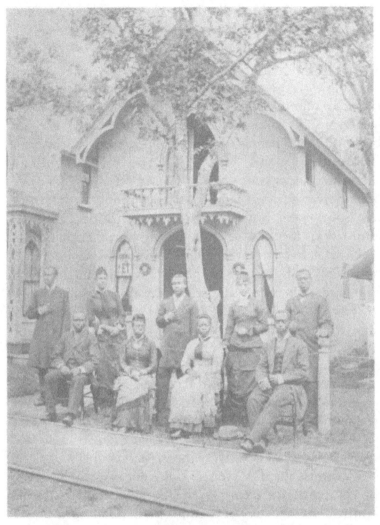

*Unidentified group outside the Thayer Cottage, date unknown. At right is a
tent with a sign that may be announcing a religious meeting.*

Highlands as an Island attraction. Smaller boarding
establishments are also noted.

Another item refutes to some extent the feeling
mentioned above about the racial attitude of the Camp
Meeting Association: "The Martha's Vineyard Camp
Meeting Association opened the Bible Vacational School

on Monday. Ruth Andrade, a granddaughter of Mrs. Carolyn Jones, was appointed teacher in the kindergarten and attended the first faculty meeting on Tuesday afternoon."

Along with the merging of the summer and year-round black communities under the spiritual and perhaps social leadership of Reverend Denniston, additional affluent black summer people began coming from Boston and surrounding areas. This small and select group of successful Blacks knew each other in Boston and followed one another to the Island. First they rented or boarded, but soon were buying homes, establishing the solid foundations for the black community in the Highlands of Oak Bluffs. Even today, though Blacks now own homes all over the Island, the core of the community remains in the Highlands, where the children of these early comers, now in their 70s or older, still live. Other summer residents came from New Bedford and Providence: the Saxons, the Fabios, the Bushes, the Douglasses, the Handys, the Harrises and the Ballos, among them.

The Boston members of the "original" summer settlers were different from Denniston's "pioneers" and perhaps more numerous and cohesive than the New Bedford and Providence community. Their life style and continuity are easier to describe. They were the Garlands, the Wests, the Richardsons, the T.V. Jones, the Dabneys, the Turners, the Cunnards, the Hemings, the Cottons, and Miss Nellie Smith. Most had ties of friendship already forged in the Boston area. There was no social hierarchy within this group. They were a community of equals, transplanted friends, a group of about forty. For the most part, the husbands did not play important roles as, then as now, the men stayed in the city and continued working while the mothers and children enjoyed a vacation.

Housing for this growing leisured black community was a mixture of small cottages for families and those for

paying guests. The two deluxe boarding houses were those of Mrs. Anthony Smith on Circuit Avenue and her Annex on Pocasset Avenue and Shearer Cottage in the Highlands.

Mrs. Smith, mother of three (Clarence, Fred and Alma) lived in the West End of Boston and supported her family by preparing meals for several Boston lawyers. One of the lawyers, settling an estate, learned of the availability of a cottage in the Camp Ground and he encouraged Mrs. Smith to buy it, which she did. According to her son Fred, when the family arrived there, they were told "we don't have niggers in the Camp Ground and you'll have to get out as soon as possible."

Summoning her lawyer friend for advice, Mrs. Smith had her cottage moved to its present location on Circuit Avenue. Later she enlarged it, purchased another house, accommodating overnight guests and serving meals for a number of years. Some older residents of today's community remember coming as children to Mrs. Smith's.

Around the turn of the century, Sadie Shearer came to the Vineyard with her parents, Henrietta and Charles, and her younger sister, Lillie, to operate a laundry service for white summer residents.[11] They employed six helpers in their business in the Highland section. In a few years, Sadie, by then Mrs. Ashburn, saw the need for a guest house catering to her own people. Closing the laundry business, she converted the building into a guest house, adding rooms and a tennis court. The opening of Shearer Cottage gave a strength and endurance to the summer community of this period as had the leadership of Reverend Denniston to the year-round residents.

For many years the most distinguished black summer visitors stayed or had a meal or two at Shearer Cottage.

[11]Charles H. Shearer, the father, was born in Virginia. He was a graduate of Hampton University where he taught. After his marriage to Henrietta, a Blackfoot Indian, the family moved to Boston where he was Maitre d' at Young's Hotel.

Henry T. Burleigh, the famous composer who came every year to Shearer, is often credited with establishing its reputation among other prominent Blacks who sometimes spent part of their vacations there. Included were Paul and Eslanda Robeson, Ethel Waters, W. H. Lewis, distinguished Boston attoney, J. E. Nail, prominent New York realtor, and Doyle Mitchell, Washington, D.C., banker.

Guests at Shearer Cottage and Mrs. Smith's came from the same social stratum as did those to Mrs. Izette's boarding house a door or two from Mrs. Smith's on Circuit Avenue. Mrs. Dora Hemings, though black, accepted only Whites at her three guest houses on Wayland Avenue.

Aside from Mr. Burleigh, the men generally identified with this period are Dr. Garland, a Boston physician, and the Rev. Adam Clayton Powell, Sr., and his son, Adam Jr. Dr. Garland bought a home in the Highlands which is still owned and occupied by his family. Like Mr. Burleigh, Reverend Powell stayed at Shearer Cottage. His son, the famous Adam Jr., later Congressman Powell from New York, first came to the Island at the age of 12. He subsequently purchased his own home in the Highlands and spent summers there with his first wife, Isabel, until their divorce.

More Blacks bought homes in the Highlands, in the main, coming from New England cities, Boston, Springfield, Providence and Worcester. According to one black person, now a year-round resident, who spent all her summers here at that time, the life style was simple, warm and relaxed. Recreation was bathing on High Beach, playing tennis and cards, and visiting with friends. The same people came year after year.[12]

Reminiscing in the *Vineyard Gazette* in 1971, Dorothy

[12]Dorothy West, "Fond Memories of a Black Childhood," *Vineyard Gazette*, June 25, 1971.

*Harry T. Burleigh with Lucy, Lilly and Sadie Shearer and a friend in front of Shearer Cottage.*

West, a long-time resident, describes this black community as "probably twelve cottages -- all Bostonians . . . neither arrogant nor obsequious, they neither overacted or played ostrich... They were 'cool' -- a common condition of black Bostonians." As the community grew, there were changes. Dorothy West describes them this way: "For some years the black Bostonians, growing in modest numbers, had this idyll to themselves . . . And then came the New Yorkers . . . [who] did not talk in low voices . . . talked in happy voices . . . carried baskets of food to the beaches... carried liquor of the best brands. . . wore diamonds . . . dresses were cut low. They wore high-heel shoes on sandy roads. . . . They lost the [High] Beach for the Bostonians."

Whether or not such a description is completely accurate is not important. High Beach was purchased for the Yacht Club to which no Blacks could belong, thus forcing them to use the beach closer to the wharf, just below Ocean Park.

At this time, summer people seemed to come more and more from the New York area and reflected the broad spectrum of New York life: they were lawyers, doctors, teachers, businessmen and gamblers.[13] The reasons for this change are many. A greater familiarity with the Island by New Yorkers, brought on, in large part, by the growing popularity of Shearer Cottage whose owner lived in New York City in winter and, of course, the popularity and visibility of the dynamic Adam Powell, Jr., were among the reasons. Additionally, the Island was becoming better known. Anne W. Simon in *No Island Is an Island* notes that the wide publicity the Vineyard was receiving in all the proper journals attracted more persons eager to enjoy its beauty and the association it offered with certain prominent personalities.

### After World War II

The Highland residential section was gradually outgrown and summer people started buying homes closer to the beach and the center of town. They were now beginning to live in what had been called "The Gold Coast," the area roughly between Circuit Avenue and the Sound, from Tuckernuck Avenue to Ocean Park. One of the most distinguished persons in this movement was Dr. Lucien Brown of New York, whose home directly across from the beach was purchased in August 1944 through the familiar technique of a "straw," using a white intermediary who would be willing to sell to a Black.

Mrs. Sally Fisher Clark of Washington bought a house near the Browns shortly after, followed by Dr. C. B. Powell, editor of the *Amsterdam News* and a New York physician. Others followed in rapid succession. These individuals and others of similar prominence never

[13]Several writers have described the changing character of the black resort communities, among them E. Franklin Frazier, *The Black Bourgeoisie*, Roi Ottley, *New World A Coming, Inside Black America*, Clair Drake and Horace Cayton, *Black Metropolis*.

*Bishop Gilbert Haven*

challenged the prominent role of Adam Powell, Jr., leading very private lives on the Island. Even Powell led a relatively restricted life here, apparently enjoying the pleasures of fishing and the company of close friends more than the flamboyant role for which he was known in New York and later in Washington.

Other Blacks, professional and otherwise, had chosen to live inconspicuously in less affluent homes along and abutting Circuit Avenue and also off School Street. The tennis courts were the center of this section which had little, if any, of the rural atmosphere of the Highlands, all the houses being located on well-paved and maintained

roads. While residents were predominantly black summer people, the area also included Whites and a few year-round Blacks.

With this increasing black population in the summer there was the start of a new style of living -- larger and more frequent parties and a great concentration of Blacks recreating on the beach along the Edgartown Road.

By the mid-fifties, Oak Bluffs was a heterogeneous black resort with summer visitors coming from all over the country and abroad. Not infrequently they came in their own boats and moored in Oak Bluffs harbor. Blacks now had homes all over the town, except in the Camp Ground. It was no longer important where you came from, but rather who you were and what was your life style.

Two other events influenced the ambience of the social environment: the arrival of Edward W. Brooke, later the Senator from Massachusetts, but not yet involved in politics, and also the establishment in 1957 of "The Cottagers," a club composed of black women who owned homes in Oak Bluffs.

Edward Brooke first came here in the early forties as a tourist. He liked the town and soon bought a house. Later, seeing the possibilities of starting a private club in the tradition of American resorts, he bought an impressive house, ballroom included, near the beach and town center, hoping to realize his objective. But this was not to be. The abutters to the house, all white, did not want any kind of club, for any kind of people, in their midst. Brooke gave up his idea. Meanwhile he started his political career which absorbed his energies and interest. Earlier he had sold his first house, which was closer to the beach, so he now decided to occupy the guest house of the intended club house, the latter he sold to his sister Mrs. Helene Amos for her year-round home some time later. Since leaving the United States Senate, Brooke has maintained his legal residence in Oak Bluffs, living in the original guest

*Guests at Promenade guest house on the plank walk running from the Highland House wharf to the Camp Ground.*

house.

The formation of The Cottagers began the institution-alizing of group status by giving some specificity as to who was or was not "in." With membership limited to 100 women, the group was started to do good works in the community and to provide fellowship for the children of members. Money was raised for a charity, usually the Martha's Vineyard Hospital at first, by an annual Clam

Bake to which anyone could buy tickets. Several years ago, the group purchased its own meeting place, a former Town Hall-Firehouse on Pequot Avenue. Used for club activities during the summer, it is available to other groups during the winter. As membership in the group has grown (there are now 86 members), it has become more diversified in the activities it pursues. The Clam Bake is still featured, but a Fashion Show, Evenings of Elegance and House Tours have been added to raise money. All events are open to the public, if they can secure the frequently scarce tickets.

Most Blacks come to Oak Bluffs to enjoy the beach, if not the swimming. Other popular activities are bridge and poker playing, tennis and fishing. Tournaments are organized annually with participants largely, but not exclusively, black. Two or three black families have their own tennis courts. The only event in which Blacks and Whites participate in more or less equal numbers is the Annual Art Show at the Tabernacle on the Camp Ground. Black artists are frequent winners of prizes there.

Of course, there are also small, intimate black cocktail parties, but increasingly popular are the "Five to Sevens" (as they are often called). These large social gatherings (up to 100 or more guests) are usually held between five and seven in the evening. To attend one must be personally invited. Drinks are plentiful and so is the food. Small talk among small groups is the main activity. Usually, there is no music or dancing and dress, while optional, is usually semiformal. If one accepts several invitations, sooner or later one must reciprocate.

Some Blacks come to the Island each summer to rest and to associate only with their friends -- no tennis, no cards, no "Five to Sevens," just the beach and small gatherings of old friends. As there is no clubhouse to which one ought to or might like to belong, private homes become a club for friends.

*Many Blacks came here to work at such places as the Narragansett House.*
*Decorations indicate photo was taken on President Grant's visit, 1874.*

There are also occasionally other activities: lectures (major civil rights leaders often come here under the auspices of the NAACP — the late Kivie Kaplan, who was white, was former president of the group and a summer resident), art shows (Lois Jones, the famous black painter and a resident of the Island since its "Boston only" period, is a frequent contributor), and concerts (Eddie Haywood, well-known jazz pianist, is a year-round resident and often gives concerts). A book party was recently given by the black community, open to all, for Dorothy West, well-known writer from the Harlem Renaissance period and another year-round resident. Her weekly column in the *Gazette* covers the activities and personalities of the black resort, but, of course, not exclusively.

In recent years, two highly visible public appointments have done much to interface the relations of the "summer" Blacks with those of the year-round Blacks. In 1977, Rufus Shorter, a black educator who had been a summer

*Promenade House is at left; Highland House is at far end of the plank walk.*

resident for years, was named Superintendent of Schools for the Island. The second was the appointment in 1980 of Herbert E. Tucker, also a black summer resident, as a Presiding Judge of the County of Dukes County. Formerly living in Boston, Judge Tucker had been a member of the black leisure class who summered here. To live here year-round meant only an extension of that life style.

Mr. Shorter died in 1981, having served only four years. His replacement was white. When Judge Tucker retires, it is unlikely he will be replaced by a black. The willingness of these two highly qualified Blacks to be part of the year-round Island community in roles not customarily held by Blacks suggests a broadening of the structure of the black community. The fact that former Senator Brooke has the Island as his legal residence also gives the year-round black community a significance that was lacking heretofore.

Other changes are occurring. More Blacks are coming each summer, purchasing more expensive homes in many parts of the Vineyard. They have become far too numerous to be known to one another or to depend upon

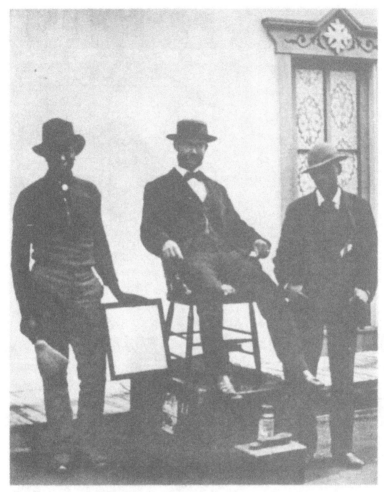

*Typical occupation for a Black in 1874: Oak Bluffs shoe-shine stand.*

one another as before. More Blacks are choosing to retire here, not only in Oak Bluffs, but around the Island. These changes suggest a more diverse resort community of Blacks co-existing with a changed and more important year-round black community.

The black presence, at first mostly in Oak Bluffs and now throughout the Island, is permanent and promising.

# FURTHER READING

Bayne, Bijan C. *Martha's Vineyard Basketball: How a Resort League Defied Notions of Race and Class.* Lanham, MD: Rowman & Littlefield, 2015.

Dresser, Thomas. *African Americans of Martha's Vineyard: From Enslavement to Presidential Visit.* Charleston, SC: History Press, 2010.

Graham, Lawrence Otis. *Our Kind of People: Inside America's Black Upper Class.* New York: Harper Perennial, 1999.

Hayden, Robert C. *African Americans on Martha's Vineyard: A History of People, Places, and Events, 2nd edition.* Boston: Select Publications, 2005.

Nelson, Jill. *Finding Martha's Vineyard: African Americans at Home on an Island.* New York: Doubleday, 2005.

Parham, Kevin J. *The Vineyard We Knew: A Recollection of Summers on Martha's Vineyard.* Plymouth, MA: Pria Publishing, 2014.

Saunders, Robert James, and Renae Nadine Shackelford, eds. *The Dorothy West Martha's Vineyard: Stories, Essays, and Reminiscences by Dorothy West Writing in the "Vineyard Gazette."* Jefferson, NC: McFarland, 2001.

Sherrard-Johnson, Cherene. *Dorothy West's Paradise: A Biography of Class and Color.* New Brunswick, NJ: Rutgers University Press, 2012.

Taylor, Richard L. *Martha's Vineyard: Race, Property, and the Power of Place.* Cambridge, MA: Harvard Bookstore/Print-on-Demand, 2016.

Weintraub, Elaine Cawley. *Lighting the Trail: The African American Heritage of Martha's Vineyard, 2nd edition.* West Tisbury, MA: The African American Heritage Trail Project, 2015.